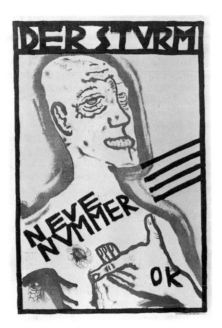

Ok

Great Modern Masters

Kokoschka

General Editor: José María Faerna

Translated from the Spanish by Diana Cobos

CAMEO/ABRAMS

HARRY N. ABRAMS, INC., PUBLISHERS

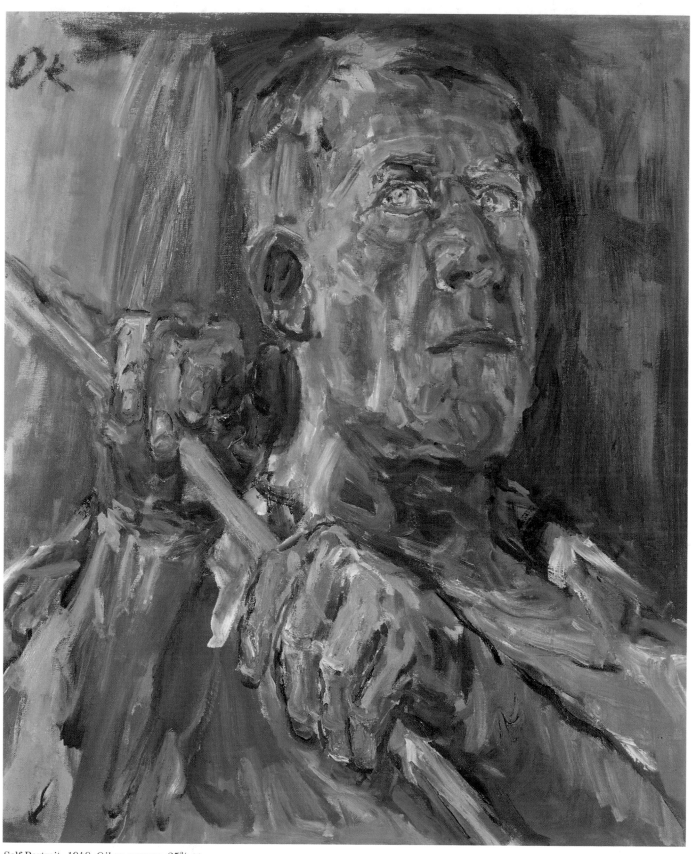

Self-Portrait, *1948. Oil on canvas, 25¾ ×*
21⅝" (65.6 x 55 cm). Private collection

Kokoschka, Chronicle of a Century

Apart from any scholarly or stylistic classification, the work of Oskar Kokoschka owes much of the place it occupies in the history of modern painting to the implacable testimony it provides about the times in which he lived. The upheavals of World War I and World War II changed the face of Europe twice during the twentieth century and the lives of many artists—particularly those of Central Europe—were altered irrevocably by these events. Kokoschka was unique, however, in the way in which he transformed and integrated his experiences into the very substance of his work.

Baroque Roots

The deepest roots of his art—evident to a certain extent throughout his long career—are to be found in Austrian Baroque decorative painting, with which he was familiar from an early age. His fascination with the suggestive, illusionist, colorfulness of the Baroque style may be linked to the *Orbis Pictus*, a kind of visual compendium of all that was known during its time, created by the seventeenth-century Moravian humanist, Jan Comenius. Kokoschka believed in the necessity of an apprenticeship of the senses as the sole means of truly liberating and healing the Western historical and cultural legacy—in Comenius he found a source of inspiration. During his life, Kokoschka wandered across Europe and his paintings aspired to the formation of a modern *Orbis Pictus*, the testimony of a penetrating look at a singularly convulsive century. In a very direct way, this painter bore witness to these clashes, which would change forever the world he had known in his youth.

Vienna at the End of the Century

Expressionism is the stylistic key to Kokoschka's painting. Outside the German-speaking cultural milieu, he was always associated with that dominant trend in the contemporary artistic scene of central and northern Europe. Nevertheless, the spawning ground of his artistic formation was that maelstrom which came to be called end-of-the-century (*fin de siècle*) Vienna—a remarkable moment in European culture when a group of artists and intellectuals, gathered together in the capital of the Austro-Hungarian empire, undertook a critical examination of all the models and usage handed down from the past. The Secession, a movement spearheaded by the painter Gustav Klimt and the architect Otto Wagner, was at the center of the reformation of taste and decorative arts that paralleled the direction of the other European modernist schools. In the first decade of the century, this was followed by a criticism of the aesthetic language of the culture. The standard-bearers for this assault were the architect Adolf Loos—first public defender of Kokoschka's work—the writer and journalist Karl Kraus, and the philosopher Ludwig Wittgenstein. For them, the social and cultural decline of the empire was reflected in a stereotypical and perverse language—both verbal and formal—that had replaced its primordial communicative mission with an entrenched strat-

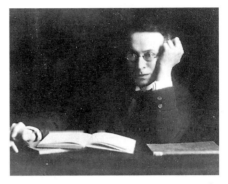

Karl Kraus, writer, journalist, and one of the most trenchant critics of the social and cultural conscience of Vienna during the last days of the Austro-Hungarian empire.

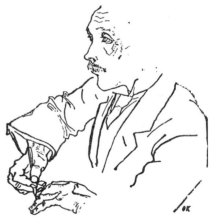

Portrait of Adolf Loos, *1910. Many portraits by Kokoschka appeared in the Berlin Expressionist art journal,* Der Sturm, *such as this drawing of his friend Adolf Loos, in which Kokoschka demonstrates his agile command of the line.*

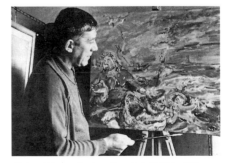

Kokoschka painting Lorelei (1941–42), *one of his most caustic aesthetic statements about the war—and a work that he completed during his exile in England.*

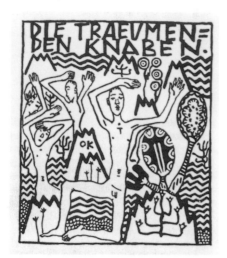

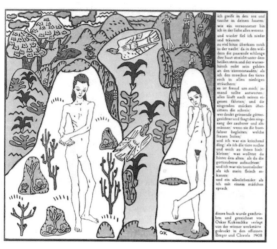

The Dreaming Youths, *1908. The flat, linear, and decorative style typical of Viennese Modernism is apparent in the lithographs by Kokoschka that illustrate this poem, dedicated to Gustav Klimt.*

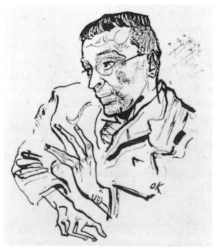

Karl Kraus, *1910. Another of the drawings published in* Der Sturm, *that emphasizes the expressive prominence of the hands, a characteristic of all Kokoschka's portraits before World War I.*

egy of mystification and masquerade. The portraits painted by Kokoschka in Vienna and Berlin between 1907 and 1914 are in alignment with this attempt at purification undertaken by Loos, Kraus, and Wittgenstein.

Portraying the World

"No portrait of modern man will remain because he has lost his human face and is returning to the jungle," Kokoschka will say years later, articulating his belief that it was necessary to delve deeper than the face to encounter the vertigo of nothingness—the true face of our time. In a certain sense, all of Kokoschka's paintings are portraits, including his landscapes and allegorical scenes. The Expressionist distortion provided the climate necessary to much of his representation. But the Expressionistic path of Kokoschka is a very individual one: it diverged from the two great trends of German Expressionism prior to World War I—*Die Brücke* (The Bridge) and *Der Blaue Reiter* (The Blue Rider)—and only his relationship with the Berlin art journal *Der Sturm* can be considered a definite connection with the trend known as Expressionism. Furthermore, he is the only one of those artists formed by *fin de siècle* Vienna (with the possible exception of Egon Schiele, who died prematurely in 1918) whose work, after having been influenced initially by the Secession, continued to reflect his early Viennese roots. It is difficult to place Kokoschka firmly within the panorama of twentieth-century painting, since his work remained apart from the historical vanguard, focused as it was upon bearing artistic witness to his times. Expressionist catalogues link him to the solid German and Central European figurative tradition that has its roots in Romanticism, but his stylistic as well as his conceptual differences with those painters whose work may appear similar at first glance—Kirchner, Heckel, Grosz—are equally clear. To exclude him from the ranks of modern painters—as has been suggested at times—would be ridiculous: in 1937, the Nazis did not hesitate to include him in their infamous exposition *Degenerate Art*, which offers the best certification of modernity imaginable.

Expressive Violence

The legacy of *fin de siècle* Vienna is apparent in Kokoschka's work throughout his long career. His paintings are, at one and the same time, mirrors and visual mechanisms that reveal the inner tension of the subject or the circumstances that they depict. The uproar caused by his first portraits is not surprising—no one was willing to recognize himself or herself in those tense images, obtained by agitating the pictorial surface with a continual scraping and the application of dense layers of paint. The violence to which he subjected his pictorial syntax is equivalent to that which he applied to the verbal syntax of his poems and plays in the first decade of the century—those veritable literary manifestos of Expressionism. The subversion of linguistic values was a resource he drew upon to mock the conventions of observation—to reinvent the visual order of the world as he felt Comenius or the Baroque painters had done. Hardly ever resorting to description, Kokoschka set himself a task that no other contemporary artist had dared attempt: to compile a chronicle using the images of his times—an interior biography of the twentieth century.

Oskar Kokoschka / 1886–1980

Born in Pöchlarn, near Vienna, Kokoschka was the son of a silversmith from Prague who endured economic difficulties due to the declining market for hand-crafted goods as new industrial products of lower quality became steadily more available. This explains Kokoschka's early enthusiasm for the currents of renewal and revindication of craftsmanship that swirled throughout the imperial capital at the end of the nineteenth and beginning of the twentieth centuries, finding their natural outlets in institutions such as the Secession or The Viennese Workshops—*Wiener Werkstätte*. In 1908 the Wiener Werkstätte Press published a picture book, *The Dreaming Youths*, with illustrations by Kokoschka, in which the flat style, as well as the linear and decorative characteristics of Viennese modernism, are still apparent. It was dedicated to Gustav Klimt, the principal champion of the Secession. At that time Kokoschka was also teaching at the School of Arts and Crafts, where he himself had studied, inspired by the example of Franz Cizek, a former professor of Kokoschka's, and one of the first to recognize the quality inherent in the younger man's expressive creations.

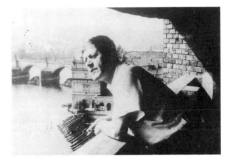

Kokoschka leaning over the balcony of his studio in Prague, around 1935 or 1936, with the Charles Bridge visible in the background.

The Black Paintings

During his first Viennese period, Kokoschka combined artistic and literary activity. His Expressionist dramas, *The Assassin; Murderer, the Hope of Women;* or *The Sphinx and the Strawman;* as well as his first portraits, were considered outrageous by both the aristocracy and the Viennese middle class. Despite the support offered by the architect Adolf Loos, who sought commissions for Kokoschka, and the reverberations from his participation in the *Kunstschau* Exhibitions of 1908 and 1909—where he saw the paintings of Van Gogh and Munch, among others—Vienna was not too hospitable. For this reason, Kokoschka moved to Berlin in 1910, with the help of Herwarth Walden, the founder and editor of the art magazine *Der Sturm*, one of the main vehicles for the diffusion of Expressionist ideas. Until the onset of World War I, Kokoschka painted many portraits of the modern Austrian and German intelligentsia, in what the painter himself liked to call his "black paintings" because they "paint the soul's dirtiness." This was the same atmosphere within which Freud was establishing the pillars of psychoanalysis.

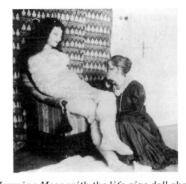

Hermine Moos with the life-size doll she made for Kokoschka in 1919.

Years of Pilgrimage

Between 1912 and 1914, Kokoschka maintained a passionate relationship with Alma Mahler, widow of the composer Gustav Mahler, celebrated muse to Rilke and Gropius, and a person of great influence within the Central European cultural milieu of the period. After World War I began, Kokoschka volunteered for the Imperial and Royal 15th Dragoons, and in 1915 he was sent to the front, where he was seriously wounded. His injuries caused him to be hospitalized several times in both Vienna and Stockholm, and he was finally discharged from military service in 1916.

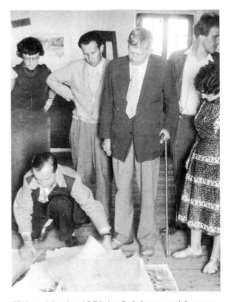

Kokoschka in 1954 in Salzburg, with some students from the School of Seeing, where he taught summer courses between 1953 and 1963.

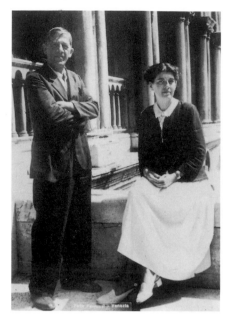

Kokoschka during a visit to Venice in 1948, accompanied by his wife, Olda, whom he had met in Prague, and married in 1941.

An image of Alma Mahler, with whom Kokoschka maintained a tormented and passionate amorous relationship between 1912 and 1914, as reflected in various paintings from that period.

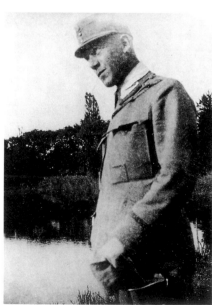

Kokoschka in uniform, on the Galician front in 1915, during his brief but intense participation in World War I.

He began to paint again and, in 1919, he was appointed to a professorship at the Dresden Academy. His paintings began to take on the edgy palette dominated by yellows, greens, and blues characteristic of German Expressionism. Leaving Dresden in 1924, Kokoschka traveled for ten years throughout Europe, North Africa, and the Middle East. After a stay in the artistic quarter of Paris, where he never felt entirely comfortable, Kokoschka eventually returned to Vienna, where he painted *Vienna, View from the Wilhelminenberg* for the Vienna Municipal Council.

The Artist's Exodus

In 1934, alarmed by the political developments in Germany, as well as Austria, Kokoschka moved to Prague. It was there that he met Olda Palkovská, who would later become his wife, and became friendly with Thomas Masaryk, the first president of the Czechoslovakian Republic and another devotee of Comenius's work. From Prague, Kokoschka raised his voice in protest against the Nazi regime in Germany, which retaliated by including his work in the listing of "Degenerate Art." The annexation of Austria in 1938, and the Nazi occupation of Czechoslovakia that year caused Kokoschka to abandon his studio on the shores of the Moldau and flee to England with Olda. Kokoschka had acquired Czech nationality, which facilitated his settlement first in London, and then in the village of Polperro in Cornwall. Many exiled Germans and Austrians who fled to England were interned as potential enemies at the beginning of World War II. Kokoschka and Olda worked to change this situation, aided by their Czech passports in this, as well as in their attempts to obtain news about their relatives in Vienna and Prague.

The Face of Terror

Kokoschka's work during the war and post-war periods alternated between portraiture and political allegories protesting the inhumanity of war. He donated and sold many works on behalf of humanitarian causes, and launched initiatives such as the lithographic poster printed in 1945 and distributed throughout England, which shows the crucified Christ with a group of children and the inscription: "In memory of the children of Europe who have to die of cold and hunger this Christmas." After the war, moved by the destruction of the Europe he had known, Kokoschka continued his activism, noting sadly: "The world to which I would like to return, through which I wandered as a happy vagabond, no longer exists." During the years that followed, his work became ever more widely recognized and appreciated, with exhibitions in Basel, New York, and Venice. Until the end of his life Kokoschka exemplified the legacy of Loos and Kraus, in the battle against mystification and dehumanization. Every summer between 1953 and 1963, he taught at the Salzburg School of Seeing, giving expression to his ideas about apprenticeship through the senses, affirming his position regarding the value of liberty, and reconstructing the world that had been destroyed before his very eyes through a series of large allegorical cycles. In 1953, he and Olda finally settled in Switzerland, near Lake Leman, which remained their home until Kokoschka's death in 1980.

Plates

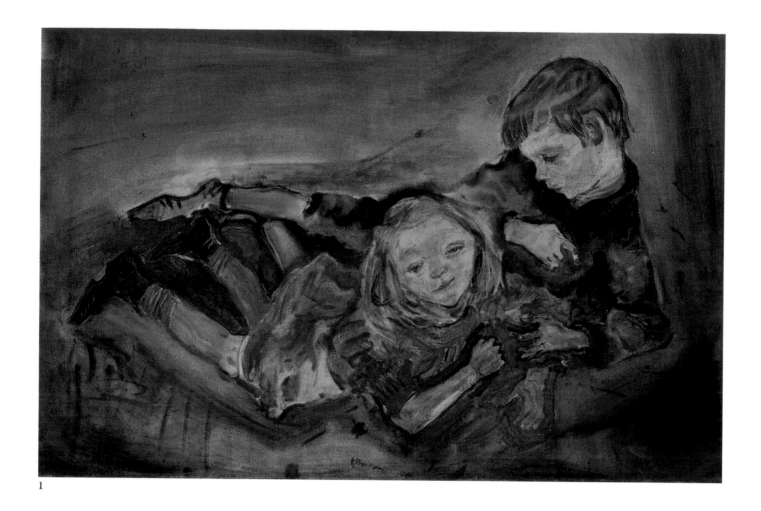

1

Vienna and Berlin

In 1909 when Kokoschka abandoned The School of Arts and Crafts and left the *Wiener Werkstätte*, he committed himself definitively to painting. His first portraits caused a public scandal in Vienna, although he had his supporters, including Adolf Loos. Kokoschka projected onto his subjects a consciousness regarding decadence and social illness that motivated the work of intellectuals like Loos and Kraus: "People lived with a sense of security although they were terrified. I perceived it in their cultivated way of life, which was derived from the Baroque period, I painted it in their anxiety and sorrow." The idea of illness as metaphor, used by many authors of the period, such as Thomas Mann, is made explicit in the portraits of people suffering from tuberculosis done in 1910. The expressive means—restricted palette, expressive treatment of the picture's surface with dense layers of paint, scraped and scored—always underlined the interior tension of the subject, as concentrated in the hands, with the elongated, interlaced fingers condensing the energies released in the painting.

1 Children Playing, *1909. The painter centers the expressive force of this double portrait in the graphic interplay of the spiral lines that determine the composition of this painting, concentrating the tension in the positioning of the heads and hands. Despite the change of style, echoes of the lithographs in* The Dreaming Youths *still persist.*

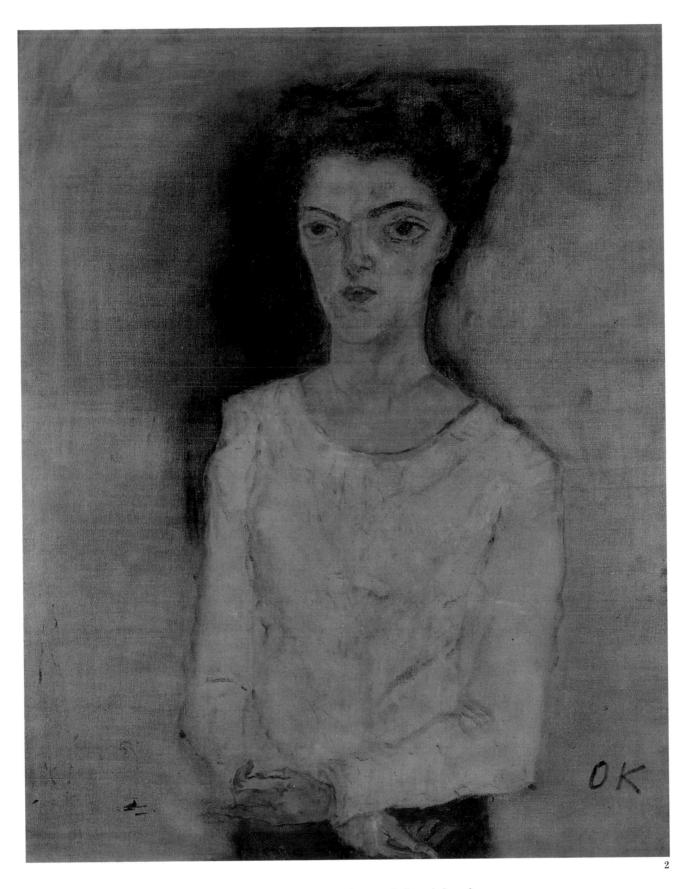

2

2 Martha Hirsch, *1909. The flat forms and almond-shaped eyes recall the decorative influence of Gustav Klimt. The nervous, expressive treatment of the hands, however, reveals the disturbing potential of the image, and suggests the influence of El Greco.*

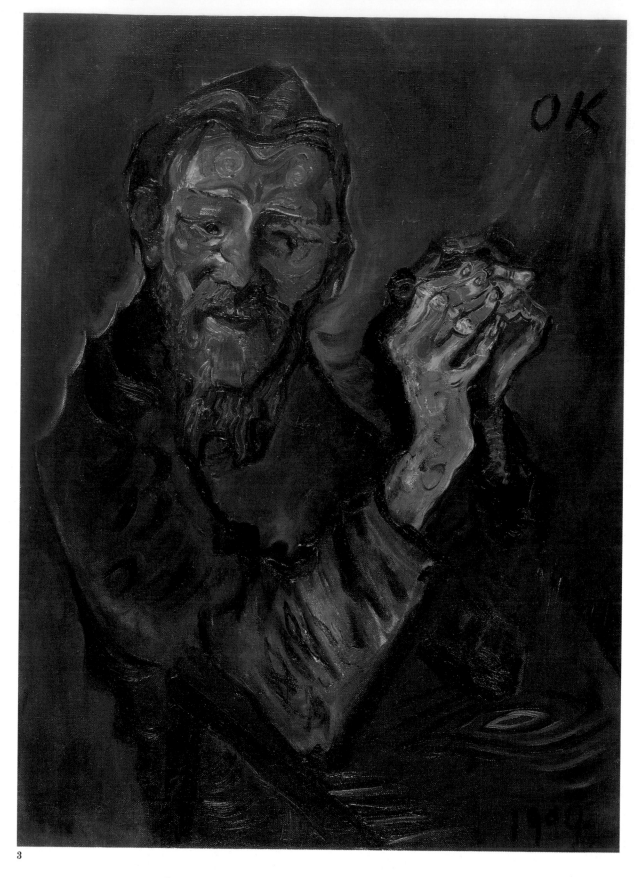

3 Felix Albrecht Harta, *1909. The swirls of red, yellow, and orange paint on the face and hands contrast with the blue aura that forms a background silhouette. The nervous and visionary quality that the technique imposes on these images shows the influence of Van Gogh, whose paintings Kokoschka saw on exhibition in Vienna.*

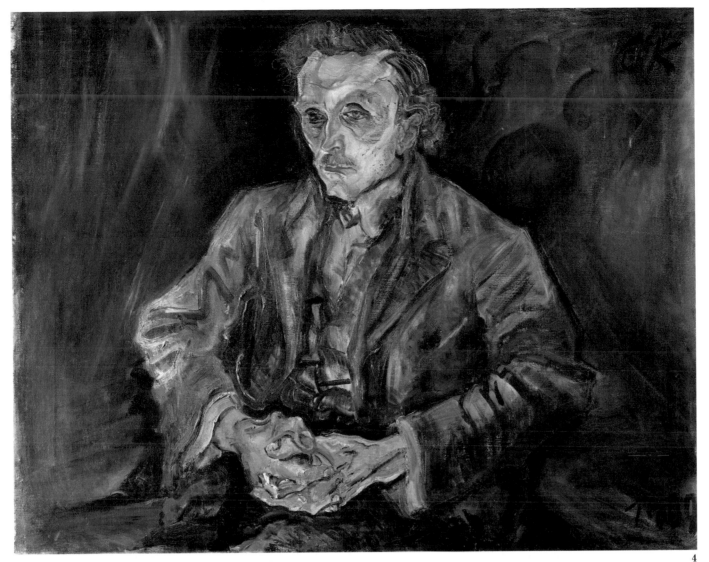

4

4 Adolf Loos, *1909. On several occasions Kokoschka portrayed the man who was one of his staunchest supporters during the early years of his career. The strong illumination on the face and powerfully clasped hands seems to highlight the firmness and independence of the great architect, who is treated here with more objectivity than the majority of Kokoschka's Viennese models of this period.*

5 Hans Tietze and Erica Tietze-Conrat, *1909. The double portrait of these married art historians focuses on an intense dialogue of hands that don't quite touch. The patches of vivid red on the hands of Hans and the slashes on the iridescent background that silhouettes his figure, seem suffused with an active tension discharging itself against, and being absorbed into the inscrutable and monumental serenity of the feminine figure.*

5

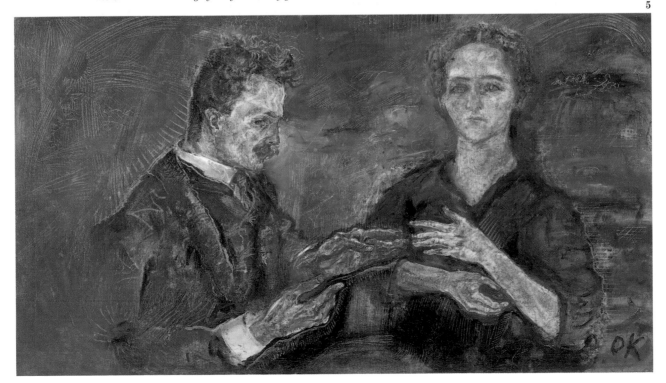

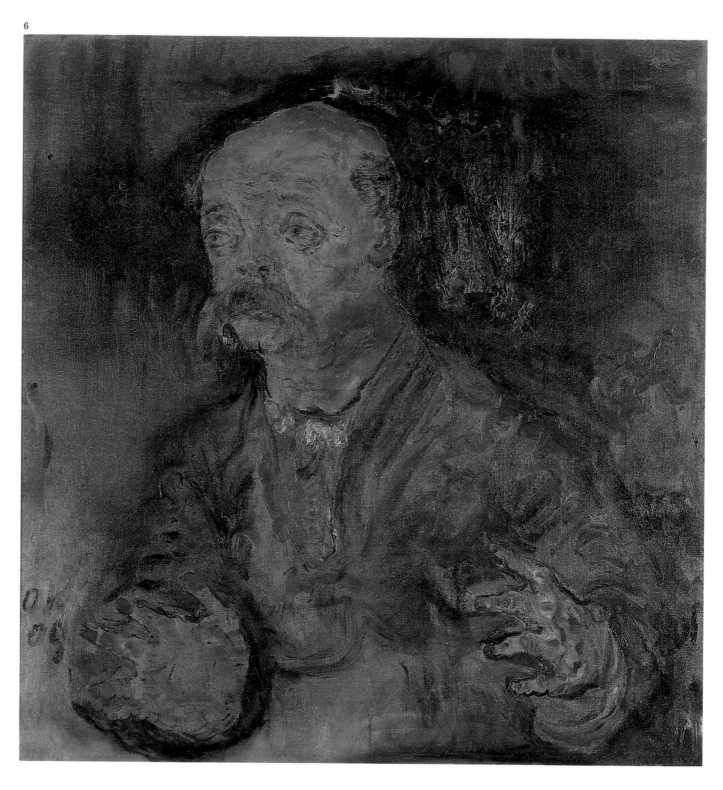

6 Peter Altenberg, *1909. Peter Altenberg was an extravagant and ingenuous poet. A friend of Adolf Loos and Karl Kraus, he was one of the most recognizable figures frequenting the Viennese cafés of that period. Kokoschka portrays him as being hardly distinguishable from the background, barely emerging from its large clumps of paint. The agitated hands and bulging eyes seem to endorse Kraus's chilling assessment of Vienna as the "training camp for the destruction of the world."*

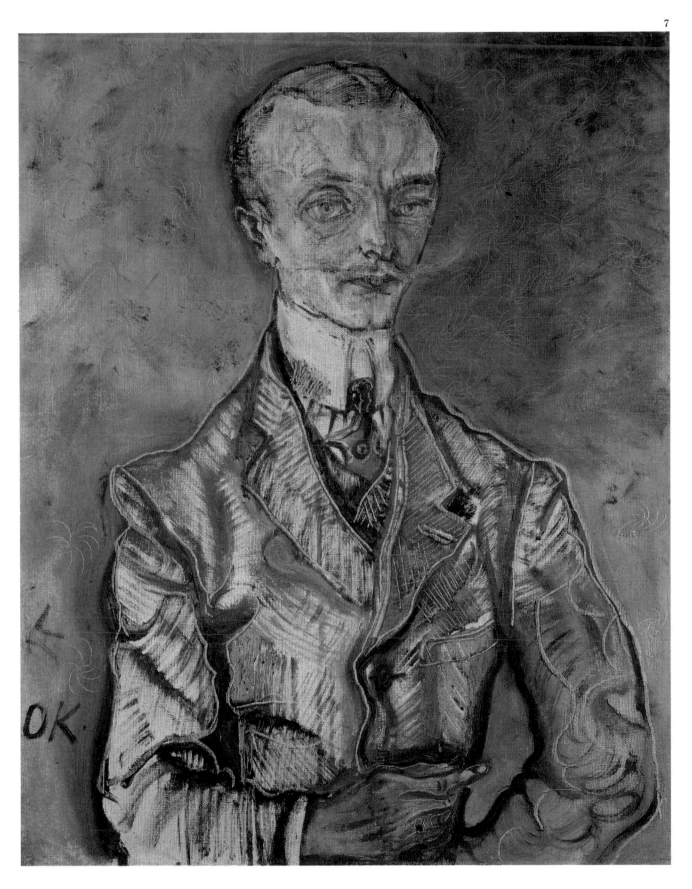

7 Joseph de Montesquiou-Fezensac, *1910. The superimposition of layers of white over a background of ochre and silvery gray produced this veritable emblem of the decadence associated with the end of the century. Consumed by tuberculosis, the pale and dignified aristocratic elegance of Montesquiou cannot successfully mask his approaching death, in an evident premonition of symbolic potential.*

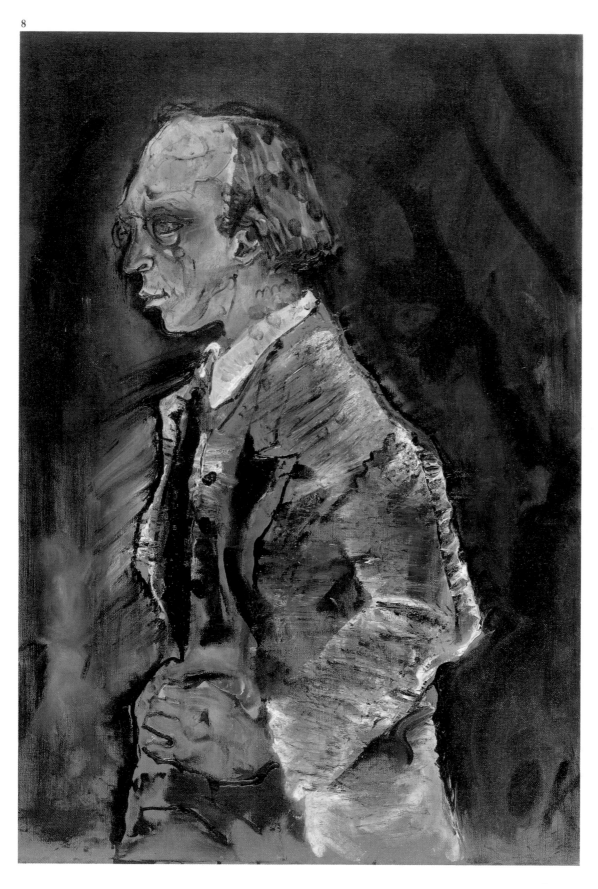

8 Herwarth Walden, *1910. Herwarth Walden was one of the principal promoters of Expressionism in Berlin through the art journal* Der Sturm, *and the gallery of the same name. Adolf Loos introduced him to Kokoschka, with whom Walden contracted to provide illustrations for* Der Sturm. *As a result, Kokoschka moved to Berlin, where he made numerous contacts among the principal exponents of the different groups of German Expressionists.*

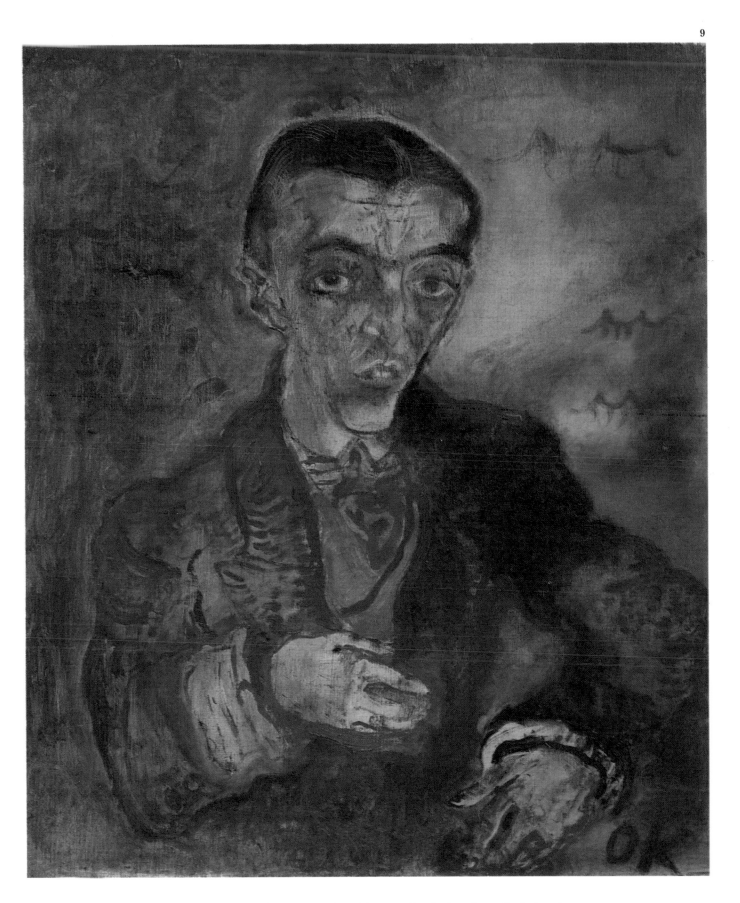

9 Count Verona, *1910. This is another of the portraits of tubercular patients done in Switzerland. The deformation of the subject and the muted, sulfurous tone project onto this man the symbolic burden of illness as a metaphor for the terminal state in which the Central European world found itself. Four years later, this society would come crashing down with the outbreak of World War I.*

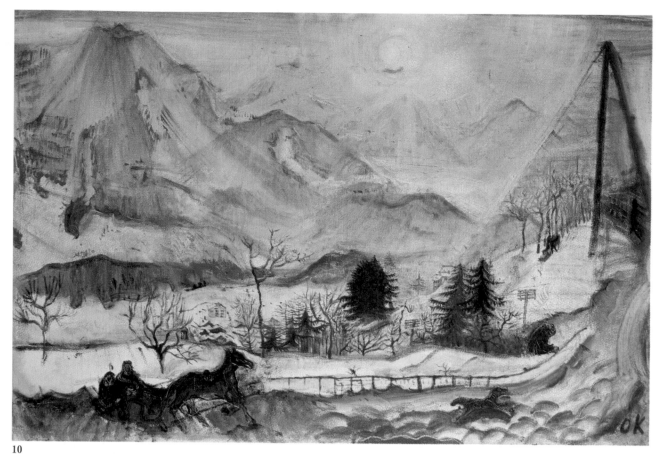

10

10–11 Les Dents du Midi, *1910*. Alpine Landscape, Mürren, *1910. Here are two of Kokoschka's first attempts at landscape. The first employs the same techniques as the Viennese portraits—layers of paint with slashes superimposed—to obtain an original study of light on different tones of white. The second acknowledges the influence of the chromatic and luminous studies done by Robert Delaunay, to whose paintings Kokoschka was probably introduced by Walden while in Berlin.*

11

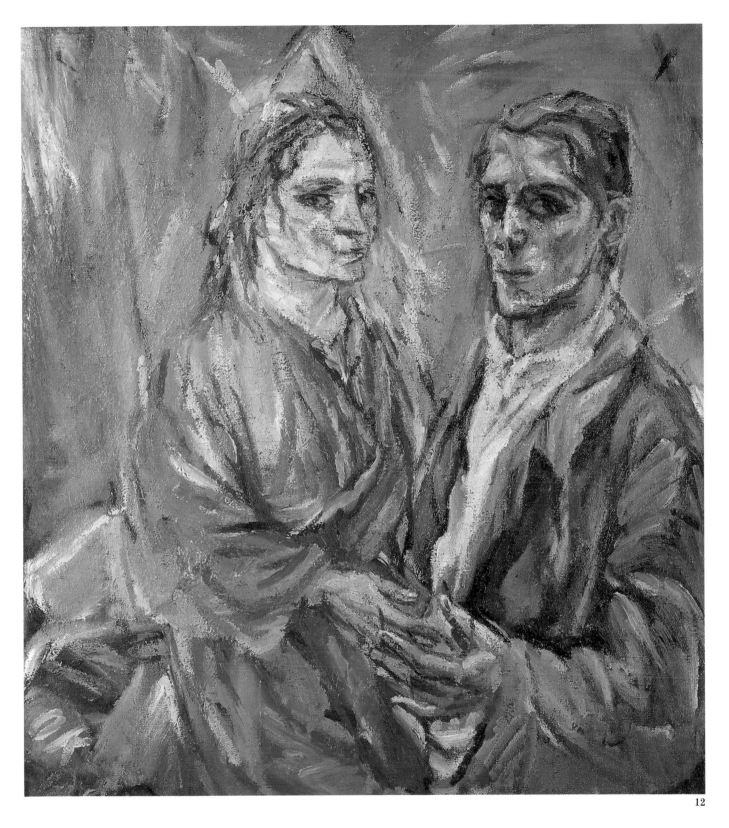

12 Double Portrait (Kokoschka and Alma Mahler), *1912–13. Kokoschka's relationship with Alma Mahler was transmuted into a series of paintings wherein the brushstroke is broader and more luminous, differing substantially from the hard, opaque surfaces of the "black paintings." A significant comparison can be made between this painting and the graphic and linear tension of the Tietze double portrait.*

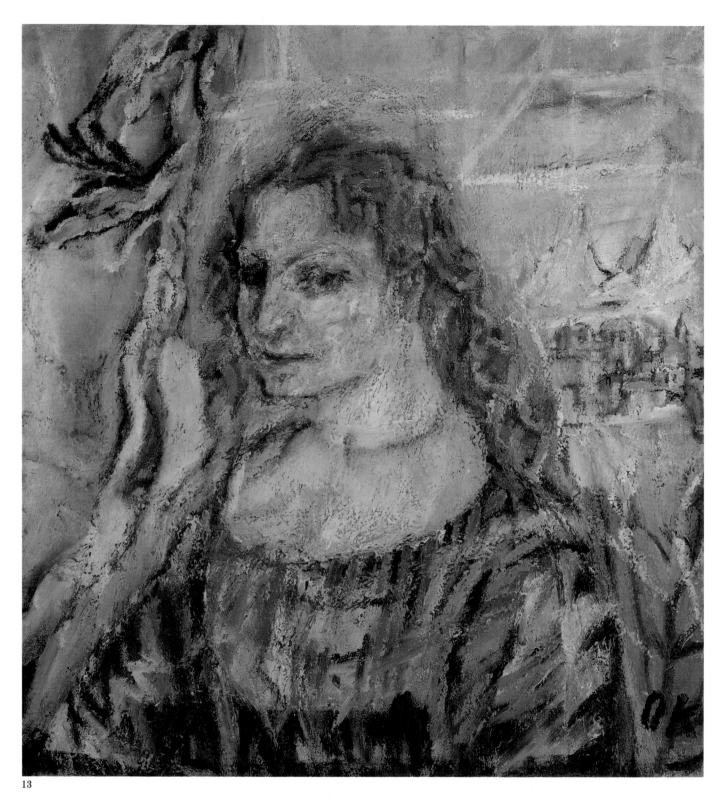

13

13 Alma Mahler, *1912. This portrait reflects not only the impact of the Baroque pictorial tradition on Kokoschka's work, but also incorporates the colors favored by Titian and Tintoretto, whose works Kokoschka had discovered during his visit to Venice.*

14 The Bride of the Wind, *1914. This is one of the poetic allegories with a very Wagnerian air (it is also known as* The Tempest*) that Kokoschka painted as a result of his turbulent relationship with Alma Mahler. As with* Two Nudes, *done in the same year, it is a Symbolist variation on the double portrait completed a few months earlier.*

15 Still Life with Cupid and Rabbit, *1913–14. A complex allegory about the destructive nature of power, this picture is a prelude to the political paintings of World War II. Here, the painter exhibits once again a dynamic brushwork and sense of color clearly influenced by Van Gogh.*

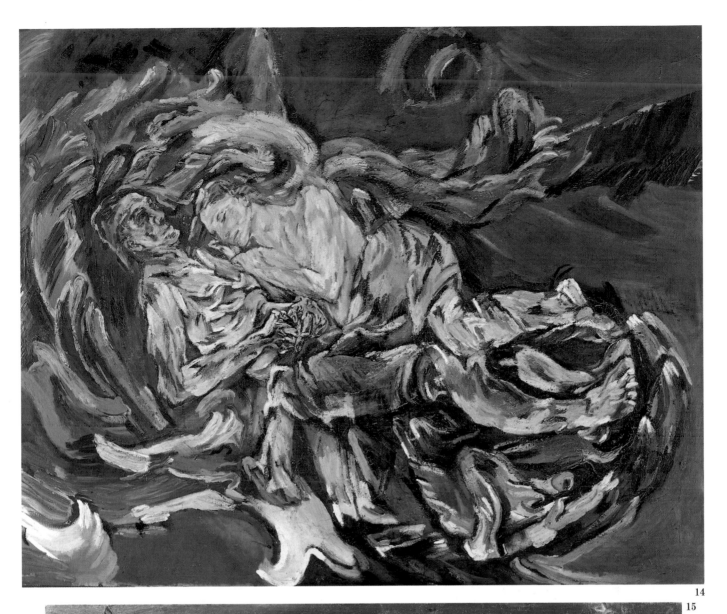

14

15

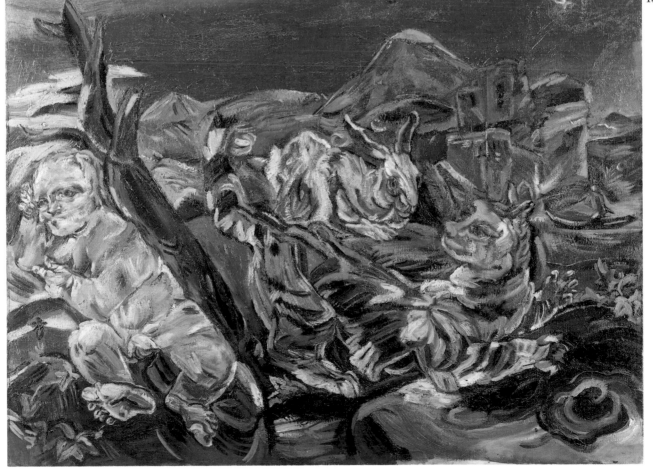

21

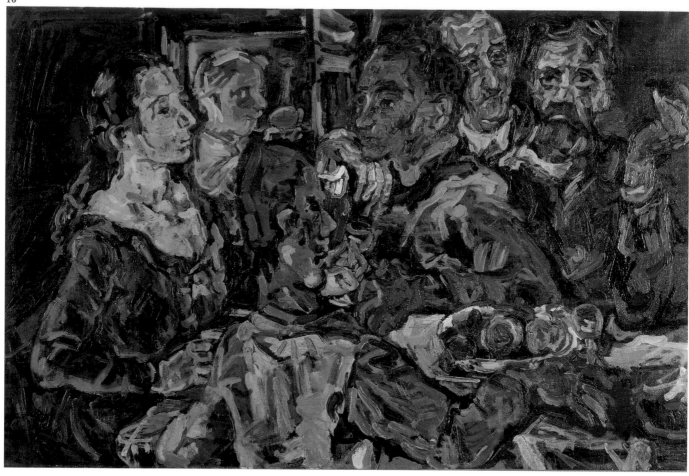

The Last Days of Humanity

With that title, intended to be more ironic than apocalyptic, Karl Kraus wrote a theater piece about the final days of the Austro-Hungarian empire and World War I. In 1916, as a consequence of that war, Kokoschka arrived in Dresden, the cradle, ten years before, of The Bridge, the first German Expressionist group with which he had already had contact before the war. In Dresden, Kokoschka widened the chromatic range of his palette, as if a confirmation of the catastrophe presaged in his "black paintings" had animated him to return to the primary elements of painting in order to reconstruct the image of a devastated world from its ashes. The surge of melancholy unleashed by his break-up with Alma Mahler caused him to commission a life-size doll in her image, which appears in several paintings. This doll seems to offer a metaphor for the emptiness of contemporary life, discernible in a number of Kokoschka's previous portraits, a pathetic reflection of the "man without attributes," from the title of Robert Musil's novel (another chronicle—like that of Kraus—about a world in the process of decomposition).

16 The Friends, *1917–18. At the beginning of his stay in Dresden, Kokoschka painted several collective portraits of the friends he had recently made: poets and Expressionist artists who had been thrown together in this northern city. This composition, which consists of several individuals on different planes, focuses the attention on the various glances that do not seem to locate the person for whom they are searching.*

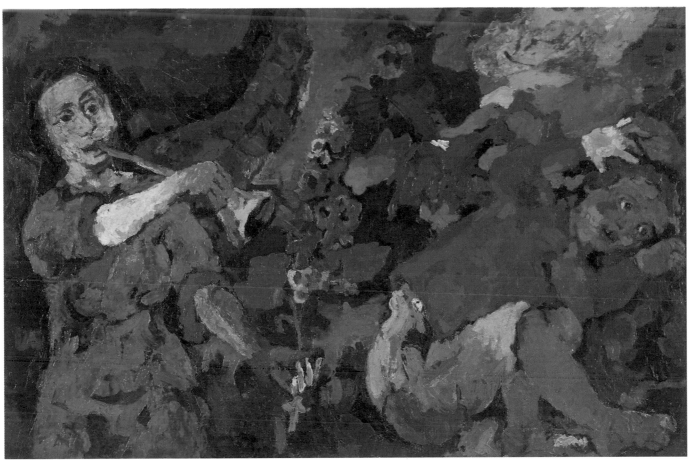

17

17–18 The Power of Music, *1920.* Self-Portrait with Doll, *1922. The use of flat textures and contrasting saturated and primary colors is similar to that in the work of painters such as Emil Nolde. The end result seems to communicate the compositional feeling of a woodcut. In the self-portrait, Kokoschka appears with the doll he commissioned from Hermine Moos— a melancholy image of his former love, Alma Mahler.*

18

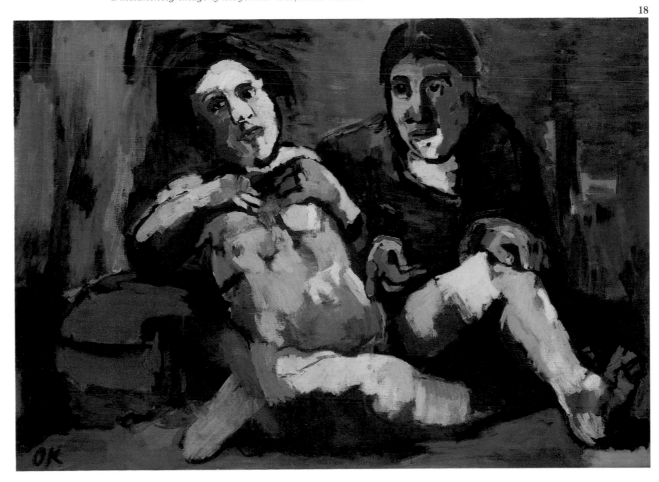

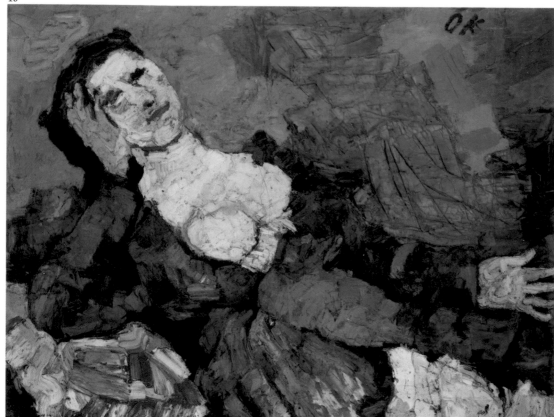

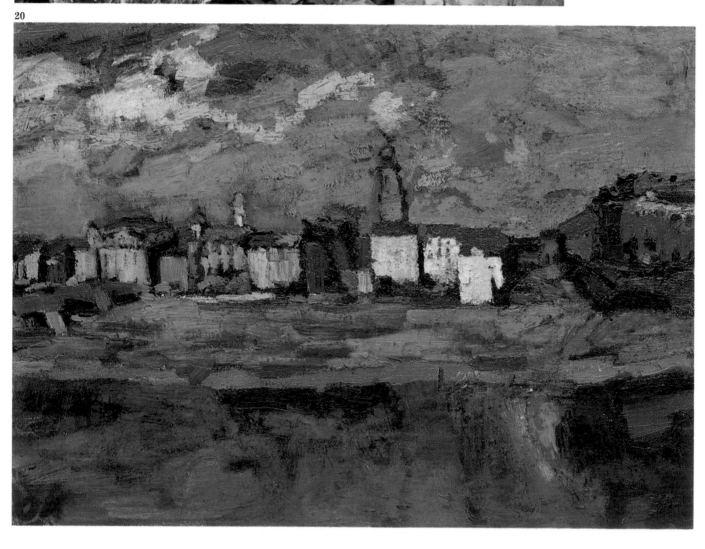

19–20 Woman in Blue, *1919.* Dresden, Neustadt II, *1921. Here are two examples of the new direction taken by Kokoschka's painting in Dresden, both in color and in texture. The influence of the German Expressionists is melded with his Baroque inheritance.*

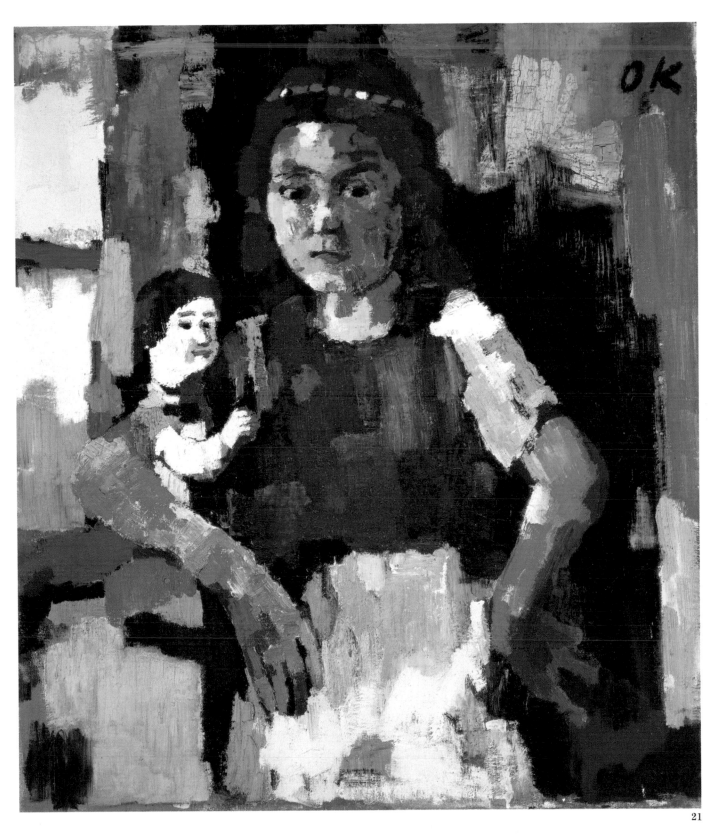

21 Young Girl with Doll, *1921–22. The spatial volumes and the flat background are constructed through the use of contrasting complementary colors. The stereotypical face of the doll contrasts strongly with the abstracted expression of the young girl, whose melancholy air adds a new register to the intense individualization of the Viennese portraits done ten years earlier.*

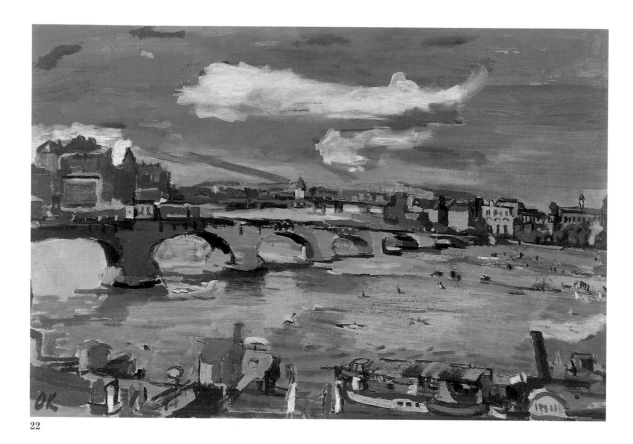

22

22–23 Dresden, Augustus Bridge with Steamboat II, *1923.* Dresden, Bridges of the Elbe
(with Figure Seen from the Back), *1923. Working in a studio in the Dresden Academy
that overlooked the Elbe, Kokoschka painted several views of the city's bridges. Thus he
advanced one of his favorite themes during this decade. Once he decided to leave
Dresden, he began a period of extended wandering through the cities of Europe, North
Africa, and the Middle East.*

23

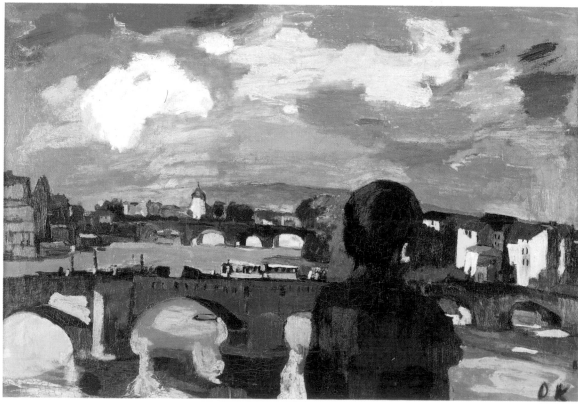

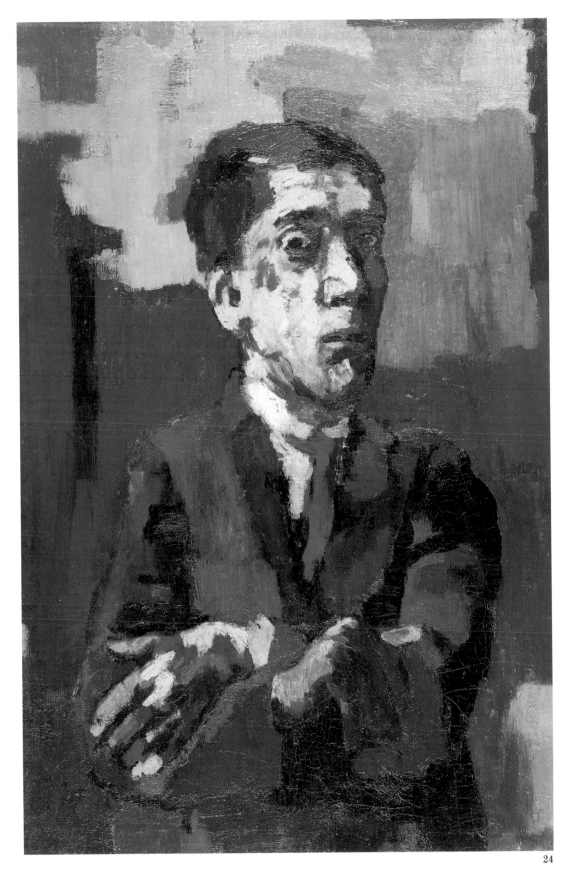

24

24 Self-Portrait with Arms Crossed, *1923. Kokoschka's first known work—a head modeled in clay and painted, which he exhibited at the* Kunstschau *in 1908—is a self-portrait. Throughout his long career, he will never abandon this genre. This picture is the first in a long series in which he always appears in a three-quarter view with his arms crossed.*

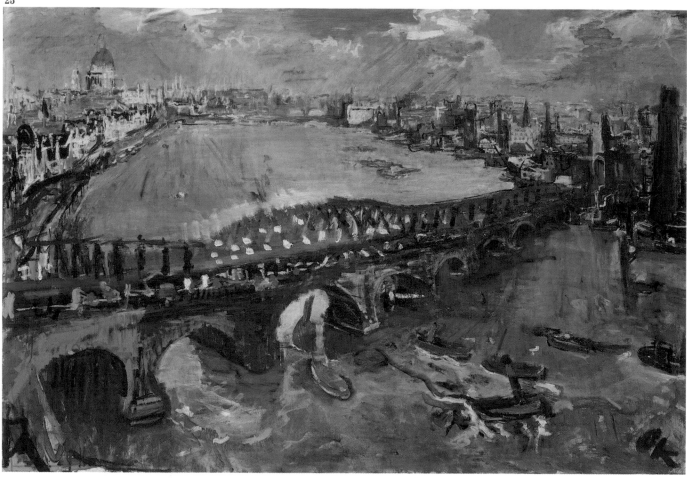

The Traveler's Postcards

Upon leaving Dresden in 1924, Kokoschka led a wanderer's life for many years, living in hotel rooms throughout Europe, Africa, and the Middle East. During that time, the painter maintained contact with friends and relatives by means of frequent postcards that provided news of his itinerant existence. That same model can be imposed upon his paintings which, like the notations of a visual compass, point to the landmarks of an artist who wished to rediscover the world after having contemplated the dissolution of the one he had once known. This new *Orbis Pictus*, like that of Comenius, whom Kokoschka so admired, contained views of many cities, a genre in tune with the Baroque tastes that he had already expressed in Dresden with his views of the bridges over the Elbe River. His painting style began to show a return to more somber techniques, as he thinned and diluted his materials until his canvases conveyed a quality akin to watercolor. This renewed interest in landscape, however, did not deter him from portraiture, as evidenced in 1926, by the magnificent paintings of animals at the London's Regent Park Zoo.

25 London, Waterloo Bridge, *1926. During a stay in London that lasted several months, Kokoschka painted the view across the city divided by the river Thames in morning and evening light. Many years later, he would paint the same view again, but under less pleasant circumstances.*

26 Nancy Cunard, *1924. The dense, compact brushwork of Dresden gives way here to a looser finish, with long strokes and so little paint in certain areas that the weave of the canvas is discernible. The comparatively muted colors in this portrait draw attention to the face of the subject, whose features seem to mimic in a strange way those of the painter himself.*

27

27 Adèle Astaire, *1926. Kokoschka painted this dancer during her stay in London, in a setting teeming with references to her profession. The composition is organized in tones of red and blue that blend harmoniously over a dense green background, with a subtle and complex gradation of textures.*

28

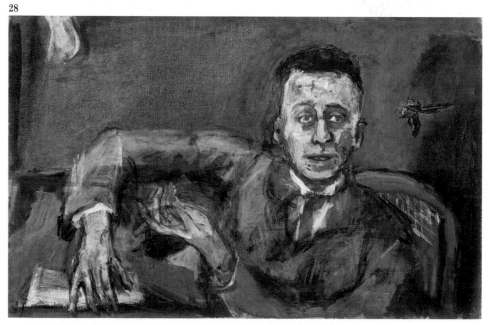

28 Karl Kraus II, *1925. A stay in Vienna provided Kokoschka once again with the opportunity to portray Karl Kraus. This picture shows the same expressive quality that is evident in the 1909 portrait of Adolf Loos.*

29 London, Panorama of the Thames, I, *1926. This was painted from the eighth floor of Kokoschka's London hotel, and he widened the field of vision to integrate various elements in the vista. The diffuse light recalls Turner's Venetian watercolors.*

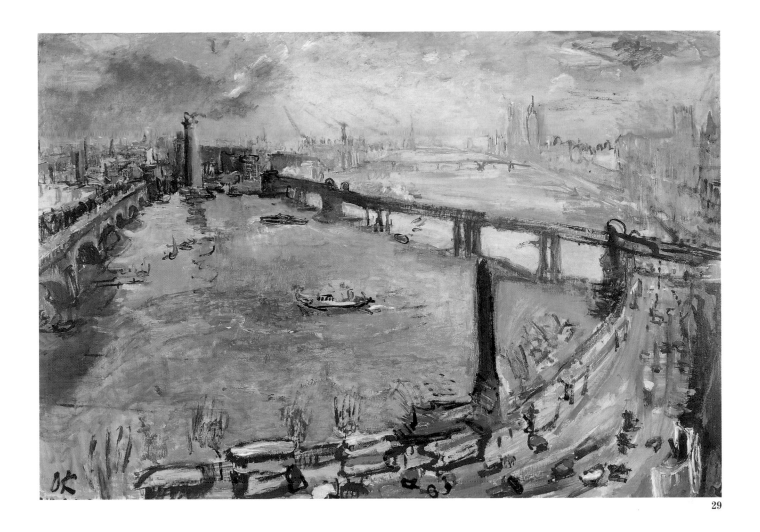

30 Tigon, *1926. Kokoschka painted several animals in 1926, after having visited London's Regent's Park Zoo, including this creature, part tiger, part lion. The dark background and fixed stare recall the intensity of Kokoschka's first Viennese portraits.*

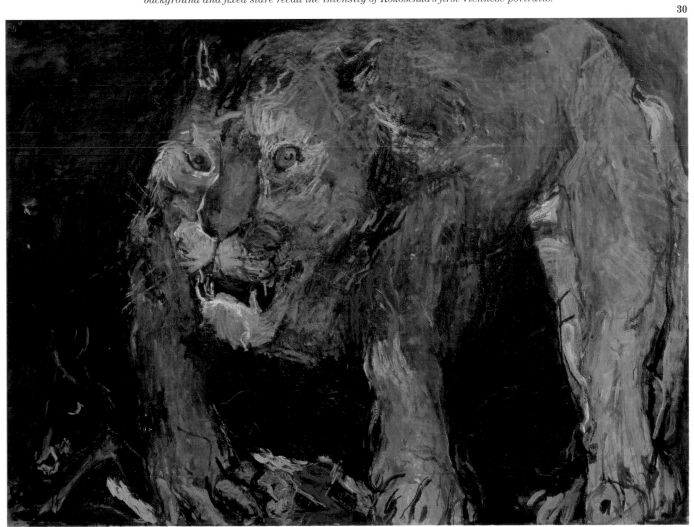

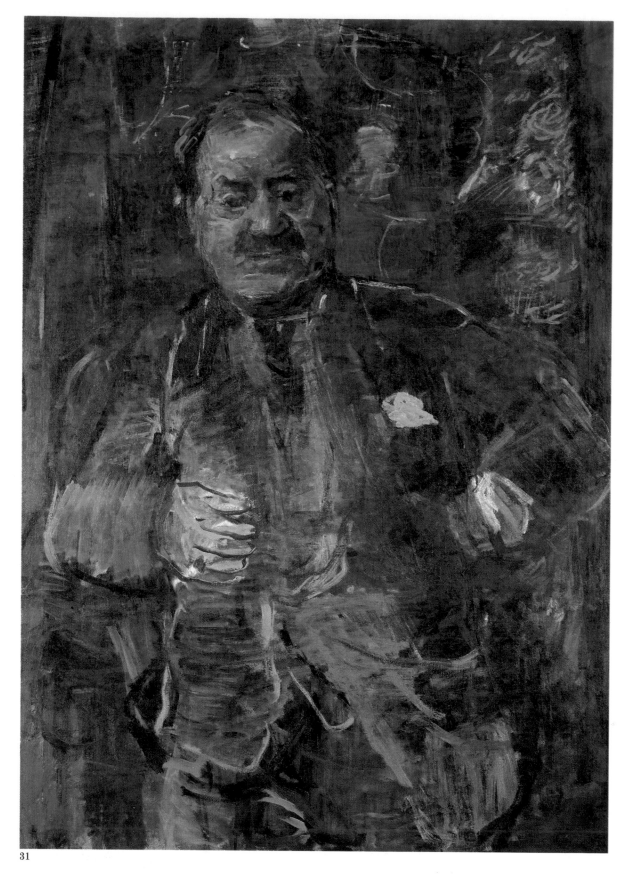

31

31 Marczell von Nemes, *1929. In Munich, Kokoschka met this well-known Hungarian collector, and portrayed him as both forceful and self-confident. In this portrait, the rounded volume of the figure is perfectly integrated with the sharp, graphic, gestures of the right hand and the lapels of the jacket.*

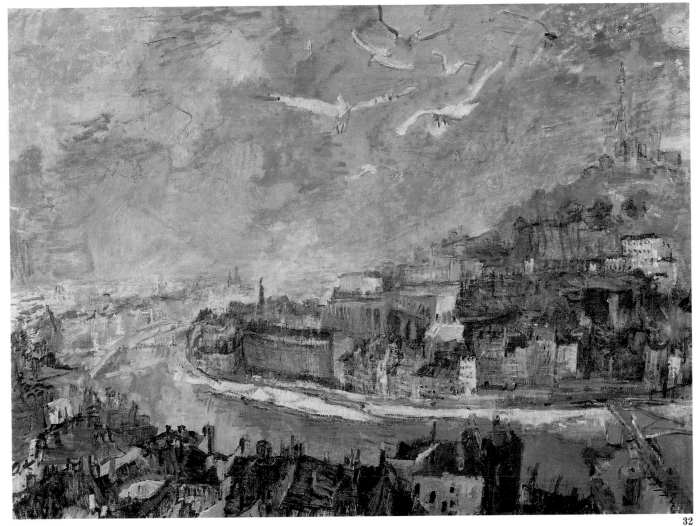

32 Lyon, *1927. The elevated point of view, and the seagulls suspended in the mist in the foreground, give the impression of a scene discovered from a window. That condition of witnessing a world suddenly revealed to the artist is a dominant factor in many of the views of cities painted by Kokoschka during his years of wandering the globe.*

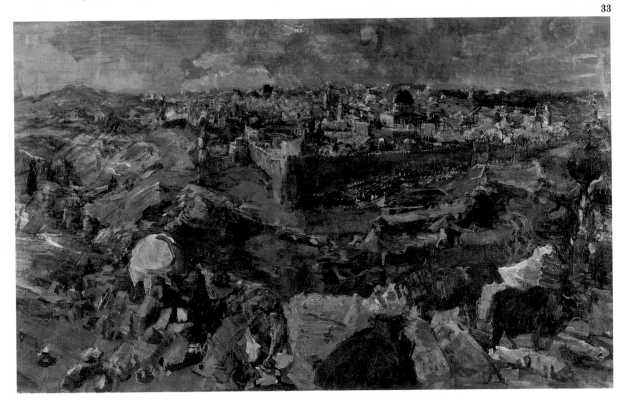

33 Jerusalem, *1929. Another city is presented from an elevated and panoramic point of view. These cityscapes seem to come alive in the vibrant brushwork, and are full of luminous shading.*

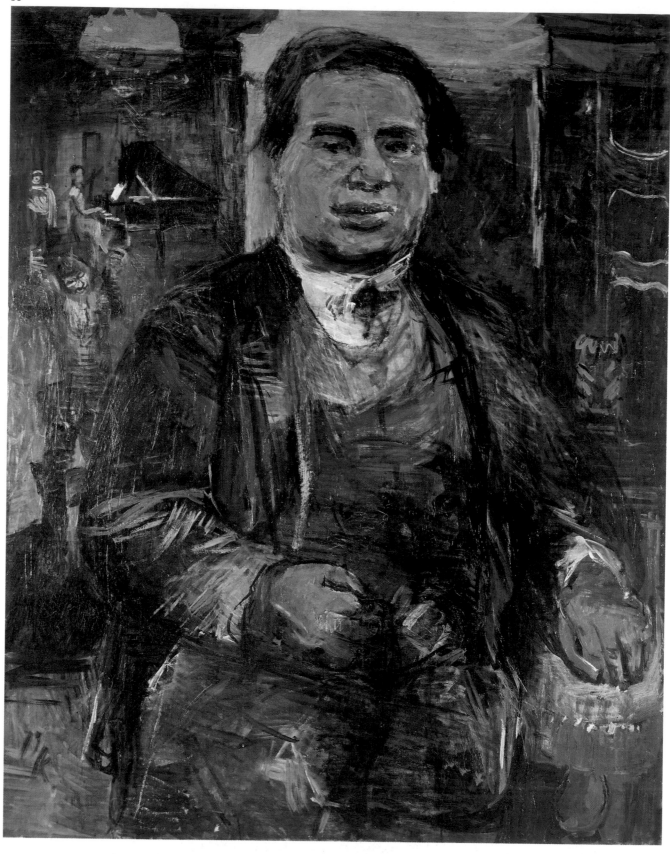

34 Leo Kestenberg, *1926–27. The portraits from this period are characterized by a major, physical presence in the volume of the figure, which occupies almost the entire pictorial surface. In contrast to the flat backgrounds of the Vienna portraits, objects or secondary scenes that allude to the personal or professional world of the subject, are now much in evidence.*

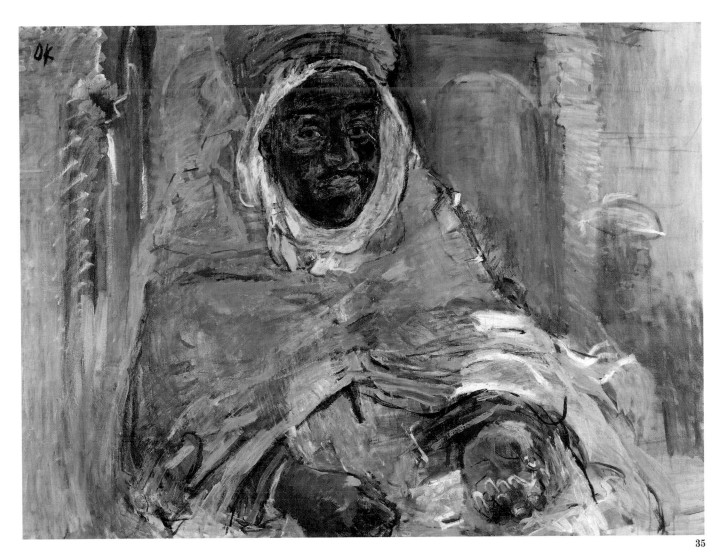

35–36 The Arab of Temacina (Sidi Ahmet Ben Tidjani), *1928.* Arab Women and Children, *1929. In these two paintings, Kokoschka presents a visual record of characteristic Arabs whom he encountered on his travels. Everything here—the broad strokes, the colors—heightens the exotic impression.*

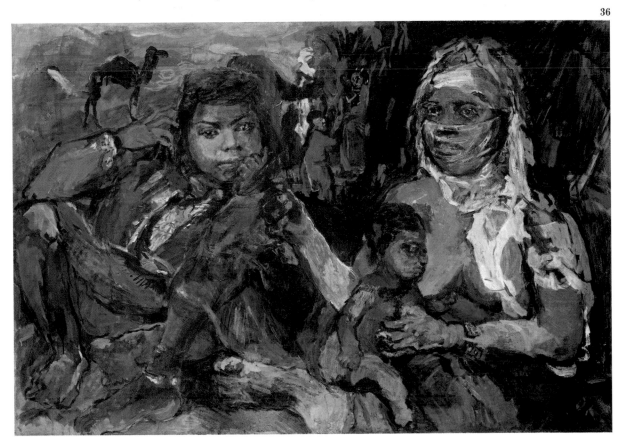

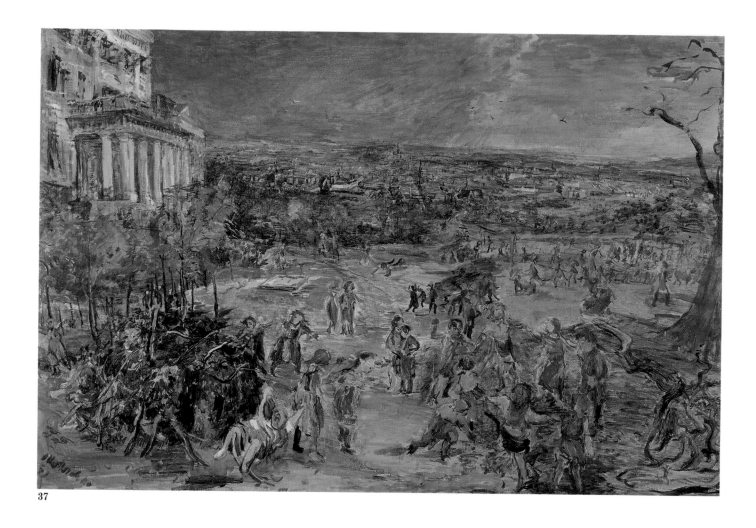

37

A Frustrated Hope

The decade of the 1930s seemed to engender hope for the reconstruction and renewal of central Europe. But the social and educational program of the Viennese city government, and the example of the cultured, humanistic Czechoslovakian Republic under Thomas Masaryk that Kokoschka encountered in Prague upon moving there in 1934, were only fugitive flashes of light between two periods of profound darkness. In 1938, Hitler annexed Austria, and the other European governments abandoned Czechoslovakia with the Munich Agreement. During the first eight years of the 1930s, Kokoschka took pleasure in playful and sensual paintings that owed much to the Austrian Baroque style. These paintings celebrated the hope of a new world in which the senses would be free to coalesce with the naiveté of an earlier time. The application of what Kokoschka had learned from the cityscapes drawn and painted during his years of wandering the globe, are recognizable in the urban landscapes of Prague seen from the Moldau.

37 Vienna, View from the Wilhelminenberg, *1931. Commissioned by the city government of Vienna, this painting shows the children of a municipal orphanage and reveals a new allegorical trend in Kokoschka's painting. Based on* Children's Games, *by Brueghel, its intention is to exalt education by means of the senses. In the background can be seen a panoramic view of Vienna.*

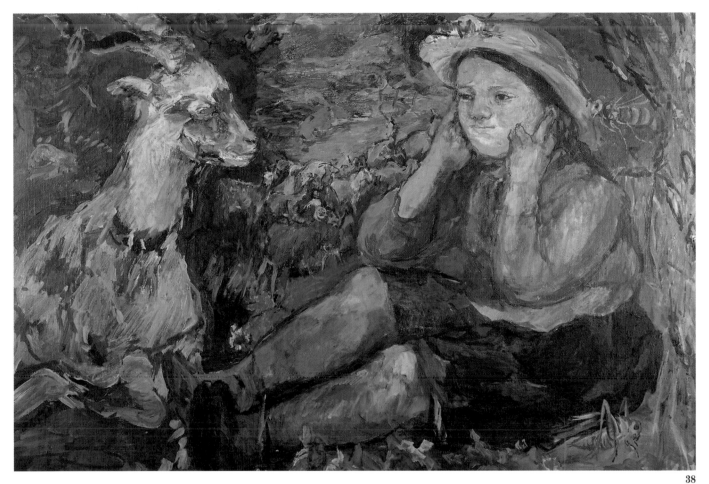

38 Pan, Trudl with Goat, *1931. Trudl was a young neighbor of Kokoschka's in Liebhartstal, who posed in various paintings such as this optimistic and musical allegory.*

39 Thomas G. Masaryk, *1936. Kokoschka was greatly interested in painting the dignified founder and president of the Czechoslovakian Republic. Here, Thomas G. Masaryk is portrayed with a view of Prague in the background and accompanied by a figure holding a book by Comenius, whom the president also admired very much. It is apparent that Kokoschka was working toward presenting a new model for official portraits, personifying the values of an era that would prove ephemeral.*

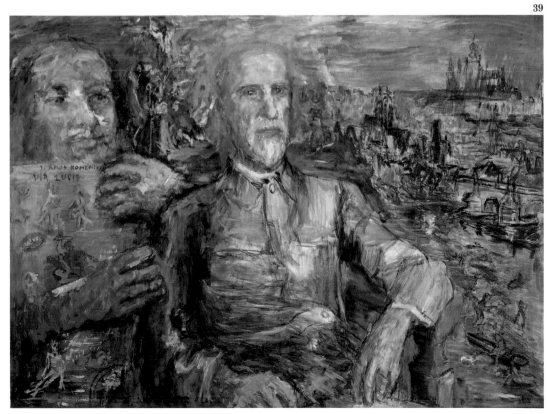

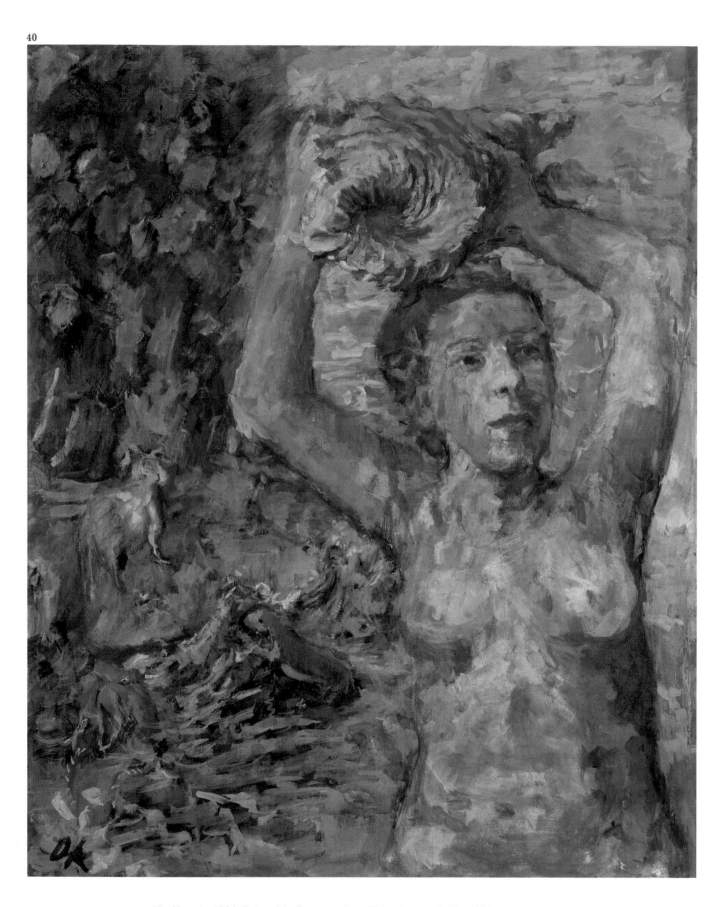

40 Nymph, *1936. Painted in Prague, where Kokoschka settled in 1934, this reworking of the birth of Venus with lively tonalities and rapid, luminous brushstrokes corresponds to the optimistic mood of the painter during this period, in both his personal and professional life.*

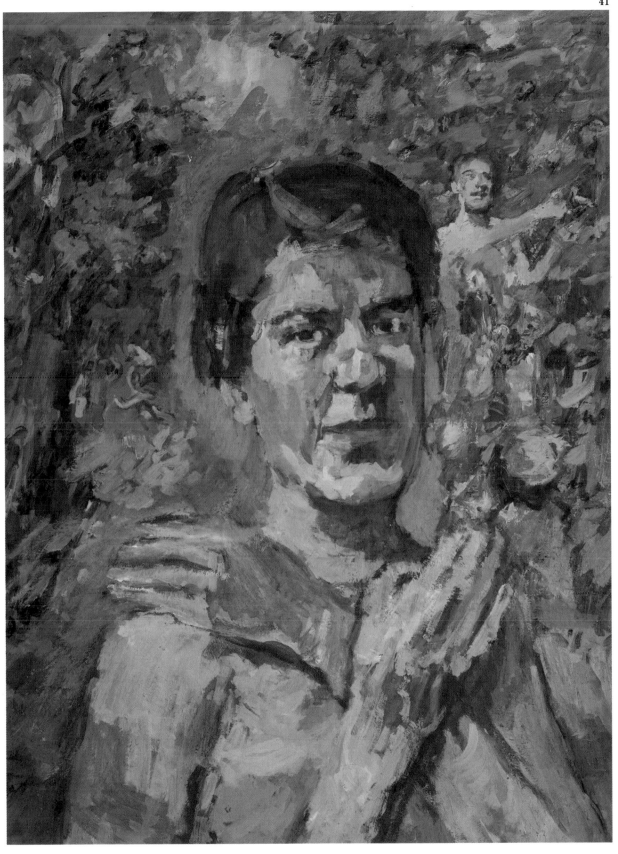

41 Olda Palkovská, *1937. The painter met this young student in Prague. They fled to England together in 1938 and were married there in 1941. Presented with an elongated torso and crossed hands, reminiscent of Kokoschka's own self-portraits, Olda is portrayed here in a bucolic and luminous atmosphere, as in the Viennese paintings of Trudl and others from the same period.*

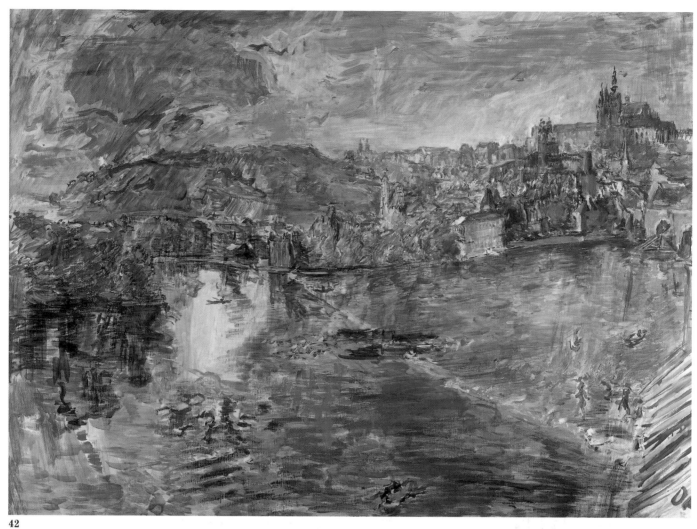

42

43

42–43 Prague, View from the Wharf on the Moldau toward Kleinseite and the Hradcany IV, *1936. Prague, Nostalgia, 1938. In Prague, Kokoschka moved into an old tower on the banks of the Moldau, next to the Charles Bridge, from which he painted numerous views of the city and the river that he so admired. The second painting is an ideal re-creation painted immediately after leaving Czechoslovakia, just before the Nazi occupation.*

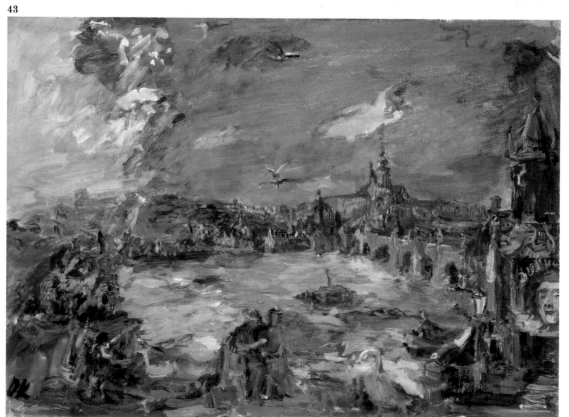

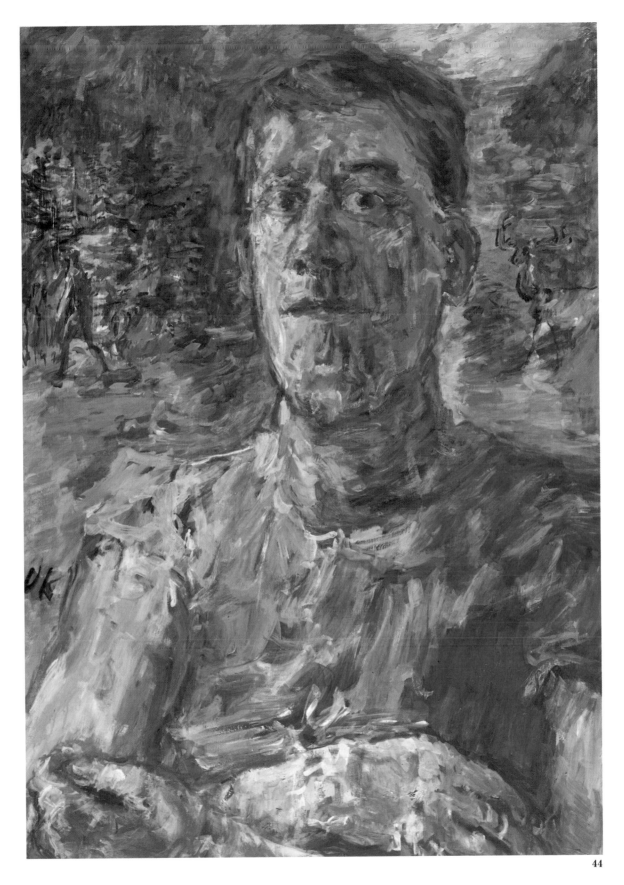

44 Self-Portrait of a Degenerate Artist, *1937. The title was a bitter and ironic reply to the inclusion of Kokoschka's work in the Nazi exposition,* Degenerate Art, *together with almost all of the great German-speaking modern artists. The deer and the hunter in the background are an allusion to persecution and flight. The painter's expression conveys the betrayal of hope born during the years between World War I and World War II.*

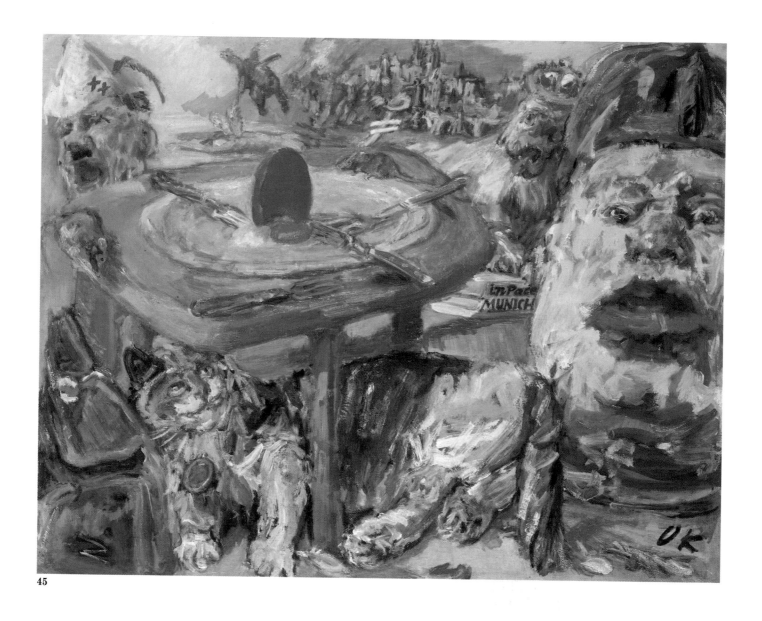

45

The Survivor's Conscience

During World War II, Kokoschka and his wife lived in England, demonstrating—together with so many others—that Hitler did not rule all of German-speaking Europe. His political allegories during this period extended the Viennese spirit of Karl Kraus, linking it with the satirical tradition of Hogarth and English caricature of the eighteenth and nineteenth centuries. These paintings—as well as many of the portraits done during these years of people in tune with his humanitarian initiatives, such as that of the Countess of Drogheda—were often donated or used by the painter to collect funds for humanitarian causes. Once more, Kokoschka survived the collapse of Europe and the values in which he believed. With the same expressive pessimism, he contemplated the immediate postwar period. The bombing of Dresden by the Allies, and the explosion of the first atomic bombs were "the logical conclusion of a mathematical attitude toward social programs," he once said, while the impoverishment of Eastern Europe weighed heavily upon his survivor's conscience.

45 The Red Egg, *1940–41. This painting was inspired by a satirical English vignette from the early nineteenth century in which Pitt and Napoleon take over the world. Here, the caricatures of Hitler and Mussolini assume the role of conquerors, and the best pictorial resources of Expressionism are allied with the venerable tradition of political satire. Kokoschka also made a lithographic version of this painting, which received wide distribution.*

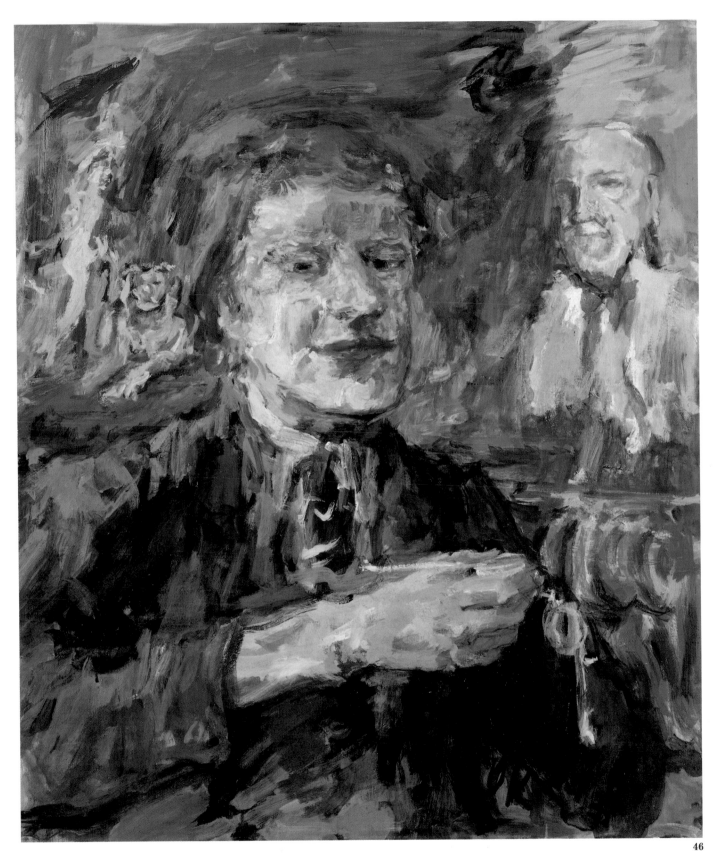

46 Michael Croft, *1938–39. Kokoschka painted a number of portraits during this period. Among the first which he undertook, immediately upon his arrival in England, were those of the art collector Michael Croft and his sister, characterized by a relaxed technique that presents the face and hands in a disembodied manner. As with other portraits from the previous decade, the character of the subject is reinforced by narrative and figurative allusions to his surroundings and personal biography.*

47

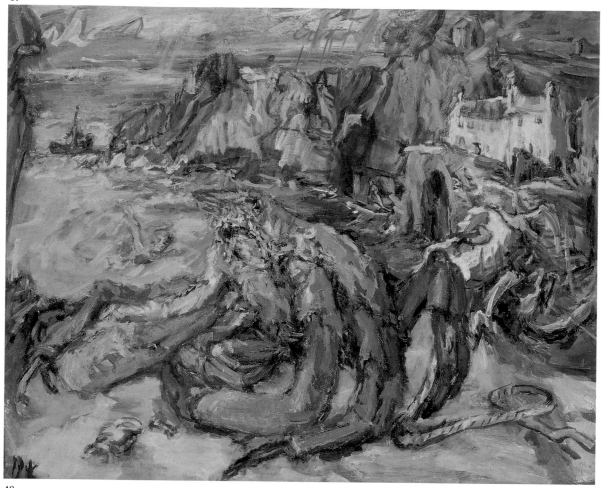

48

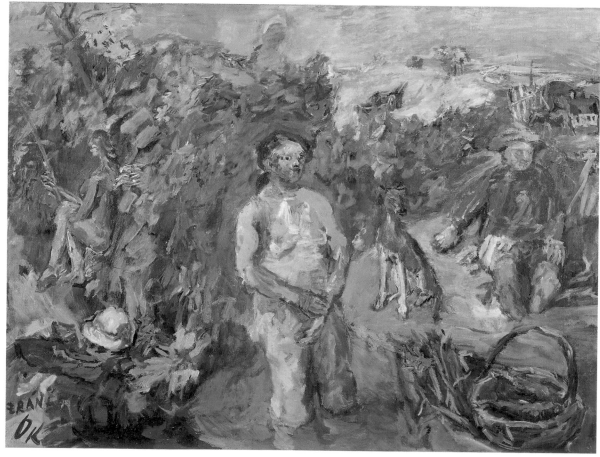

47 Sea Spider, *1939–40. Here, a giant crustacean is portrayed as threatening the port of Polperro, where Kokoschka settled for some time. This sea creature represents Chamberlain and his policy of placating the Nazis, while the bather is Czechoslovakia, abandoned to Hitler in 1938.*

48 Summer II (Zrání), *1939–40. Although his production during this period was strongly influenced by the onset of war, Kokoschka did not abandon landscape painting or the portrayal of intimate bucolic scenes such as this one.*

49 Anschluss, Alice in Wonderland, *1942. This bitter allegory once again unites the tradition of English political satire with Baroque influences in the coloring and nervous brushwork—on this occasion referring to the physical and moral destruction of Kokoschka's native city after the annexation of Austria by Hitler.*

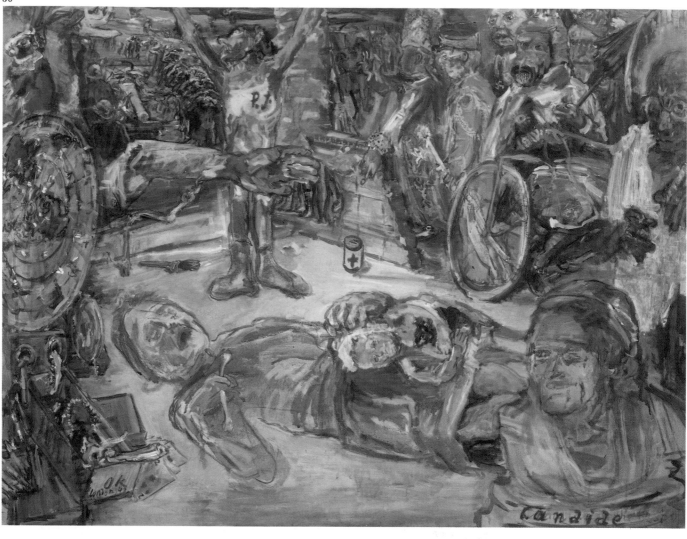

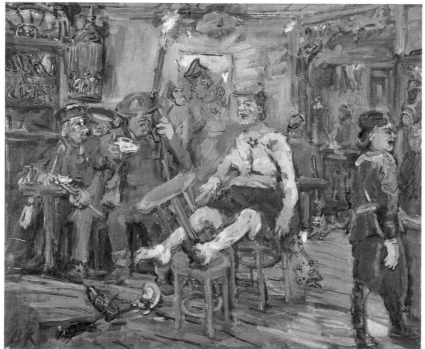

50 That For Which We Fight, *1943. This is without a doubt the most frightening of the political allegories painted by Kokoschka about the war. The graphic intensity of the dead mother and her child, contrasts powerfully with the yellow tone of the ground, achieving a new level of acuteness that had not been apparent since Kokoschka's Viennese "black paintings."*

51 Marianne-Maquis, *1942. The sense of space, the overall composition, and the bright coral accents all testify once again to the influence of a series of eighteenth-century satires by Hogarth upon Kokoschka's painting, especially while he was in England.*

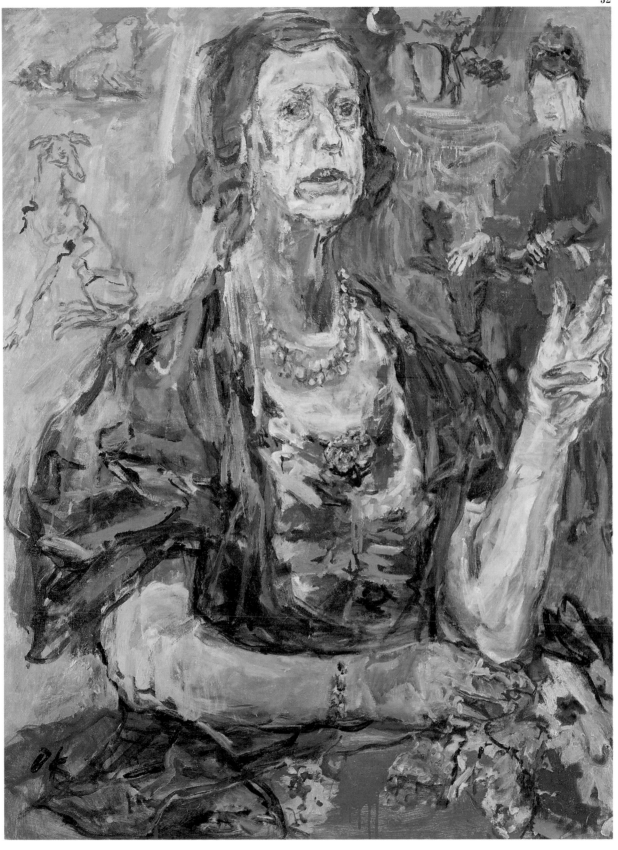

52 Cathleen, Countess of Drogheda, *1946. During the course of World War II and in the years immediately following, Kokoschka painted many portraits, including this detailed and colorful picture of a supremely confident Lady Drogheda. Here, the viewer can appreciate Kokoschka's mastery of impasto, and the overall effect achieved by the integration of rapid, fluid brushwork.*

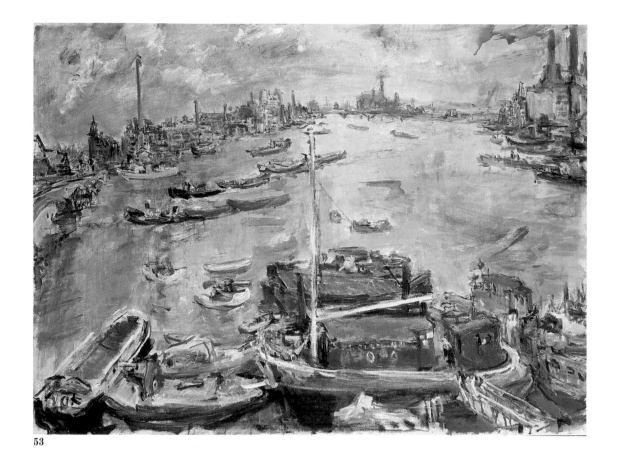

53

The School of Seeing

Since the 1950s, it has been difficult to deny the moral and artistic stature of Kokoschka. His activism on behalf of the reconstruction of the values of European culture, made him one of the strongest defenders of an independent and democratic Austria after the war. For ten years, from 1953 to 1963, he put into practice his original ideas about artistic training, based on the visual experience, in a series of summer courses that he taught in Salzburg at The School of Seeing. The portraits, landscapes, and urban scenes of the final stage of his career displayed a renewed spirit of optimism. Kokoschka remained faithful to his conception of painting as being an expression of the world, and humankind's experiences in it, which distanced him somewhat from the paths explored by the artistic vanguard of his time. His artistic vitality, however, never decreased, and his later work benefited from a technique ever more fluid and responsive to the requirements of the painter's continually attentive gaze.

53 London, Chelsea Reach, *1957. Of all Kokoschka's work during this period, his urban views are perhaps the freshest and most appealing, demonstrating his ever greater control over the portrayal of panoramic space and the subtle gradations of light.*

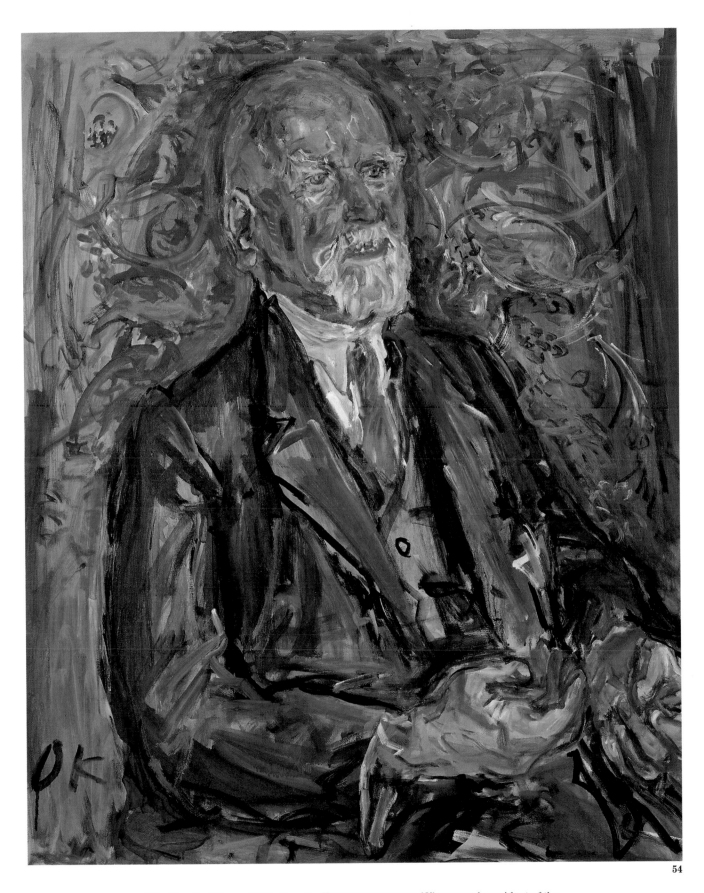

54

54 Theodor Körner, *1949. Theodor Körner was mayor of Vienna and president of the new democratic Austria, which Kokoschka always defended. This portrait represents a civic act upon Kokoschka's part, as had been the case with the portrait of Thomas G. Masaryk, in its time. Here, the painter provides a strong counterpoint in the outline of the hands and the exploration of the expressive possibilities in the pictorial material—note especially the face and the background.*

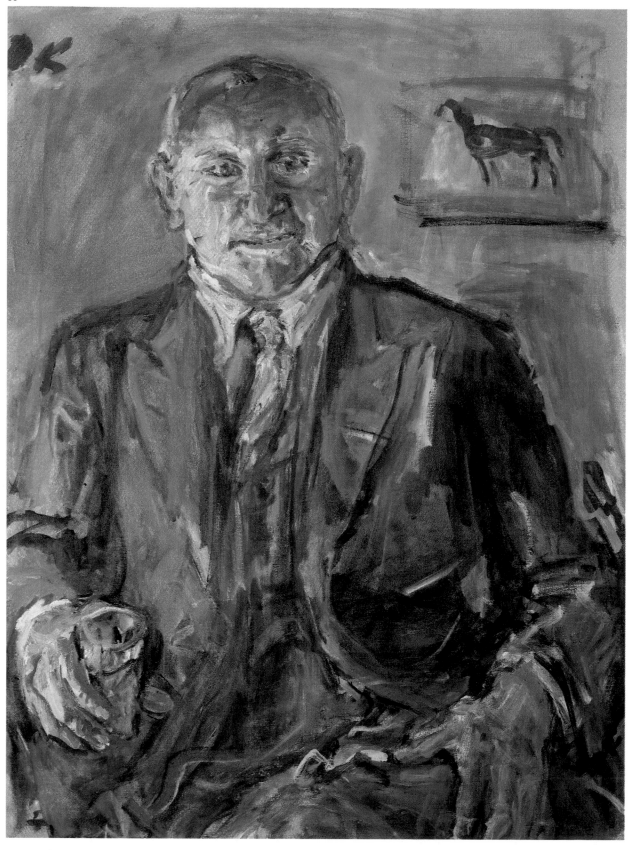

55 Louis Krohnberg, *1950. This is one of the most sensual and Baroque portraits that Kokoschka painted during this period. The brushwork has been converted into an instrument for the representation of volume, alternating zones of nervous lines and thick layers of paint with areas in which the paint refines and extends the light that envelops and projects the forms.*

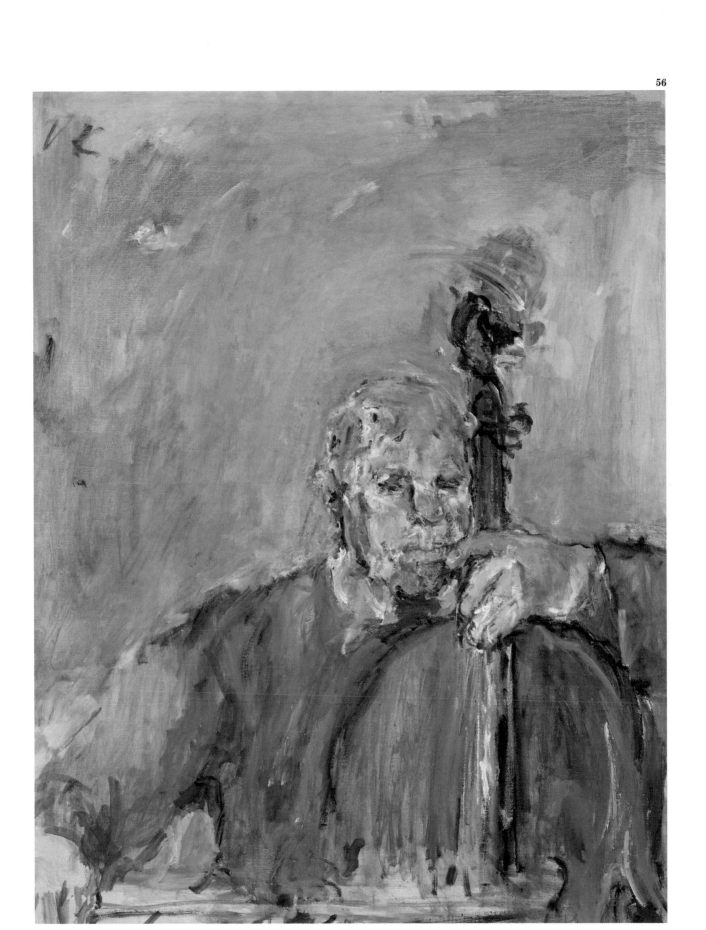

56 Pablo Casals, *1954. The sweep of the brushwork—long and fluid in the lower part of the painting—the overall composition of small, rapid touches of red, blue, and yellow, as well as the enveloping, vaporous finish of the background, all demonstrate the varied repertoire of techniques that Kokoschka brought to bear in painting this portrait of the famous cellist.*

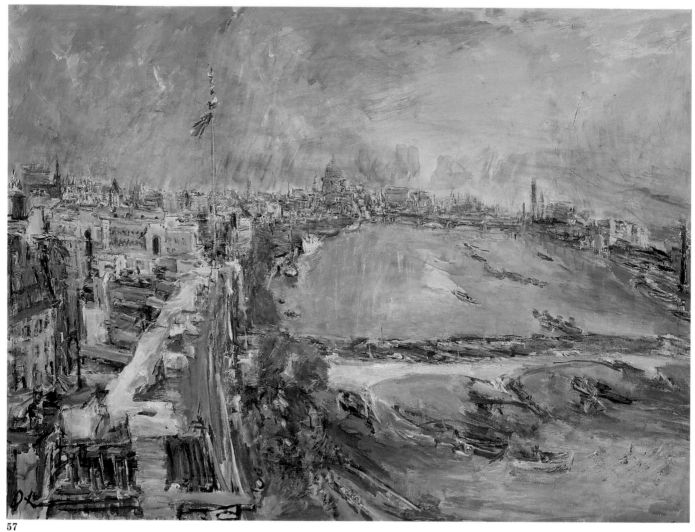

57

57 London, View of the Thames from Shell-Mex House, *1959. In this painting, the space curves to integrate two consecutive points of view, and the city appears to be a living organism with the light sifted through a fine curtain of wind and rain.*

58 New York, Manhattan with the Empire State Building, *1966. This view of New York and that of Berlin during its reconstruction (painted the same year), represent the most important work done by Kokoschka in this period, as the artist bears witness to a world rising up again from its ashes.*

58

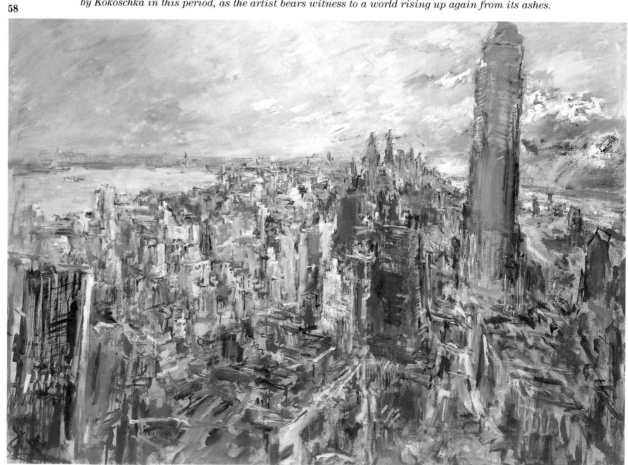

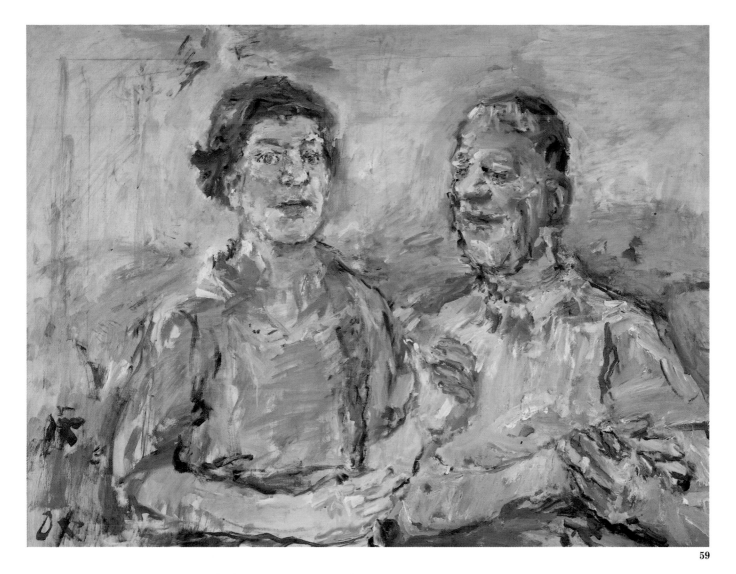

59 Self-Portrait with Olda, *1966. This picture marks Kokoschka's return to the double portrait—a great tradition in German painting—and a form of representation he had ceased to explore since those which had referred to his relationship with Alma Mahler. The contraposition of the two heads and the interplay among the hands constitute essential elements in this affecting portrait.*

60 Lake Leman with Steamboat, *1957. After 1953, when Kokoschka moved to a small house in Villeneuve, Switzerland, with his wife, he painted numerous landscapes with Lake Leman as a central element.*

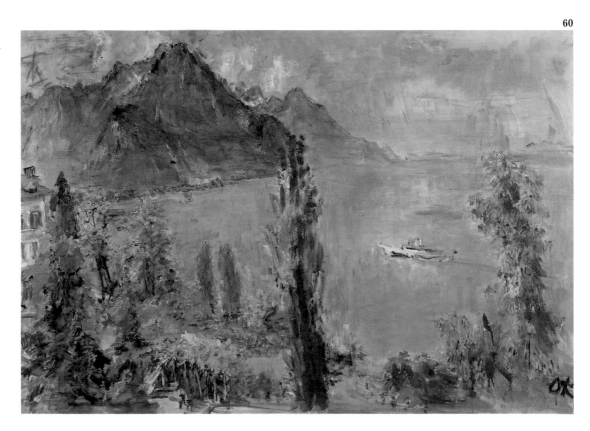

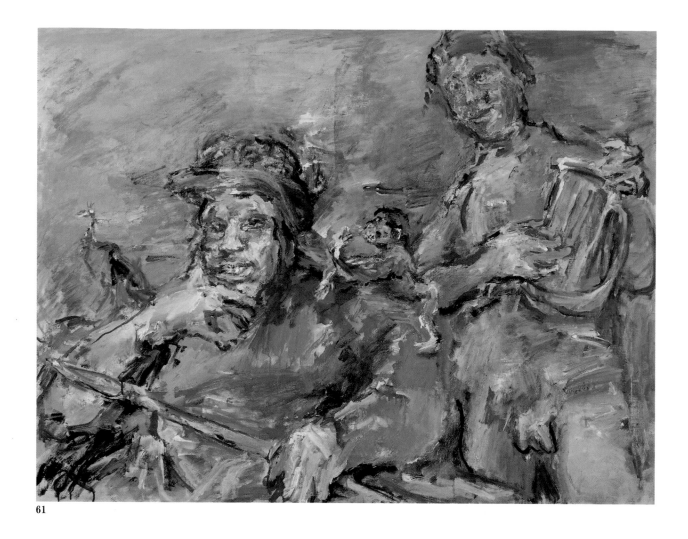

61

Allegories for a New World

Kokoschka spent his infancy close to the monastery of Melk, one of the jewels of Austrian Baroque art and architecture. The large magical frescoes of decorative Baroque are one of the fundamental inspirations of all of Kokoschka's paintings. To a great extent, his Expressionism reflects a development of the intense and revealing dynamism of Franz Anton Maulpertch's Baroque painting, or of the nineteenth-century neo-Baroque historian Anton Romako, the painters that most influenced his early formation. But it wasn't until his later years that Kokoschka was presented with the opportunity to undertake a large allegorical cycle in the style of the seventeenth-century painters, with *The Myth of Prometheus*. During the 1950s and 1960s, Kokoschka completed several more allegories of this type, always drawing upon the idea of the values that constitute European civilization. At the end of his life, in the manner of a legacy for posterity, Kokoschka channelled the sources of his pictorial inspiration and the principles of his moral posture into these allegories, a heartfelt declaration of hope for the future of a world that he saw once more rising up powerfully from its own ruins.

61 Saul and David, *1966. In this painting, Kokoschka revitalized the biblical theme with a maximum concentration on expressive resources, making a powerful point in the contrast between the warrior-king and the poet-king.*

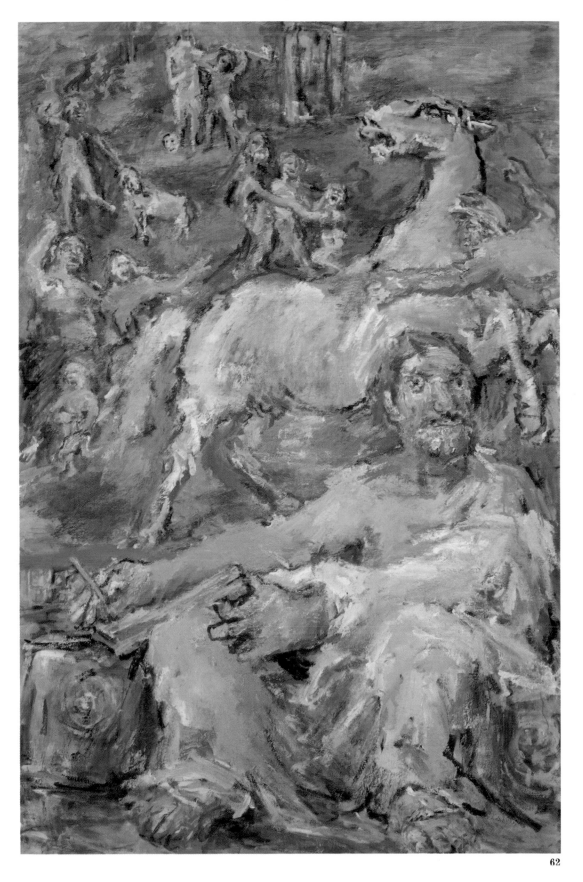

62

62 Herodotus, *1960–64. Here, Kokoschka proposes an image of the great Greek historian as the emblem for memory. The chromatic whirl of the painting centers on Herodotus's direct, inquisitive stare, as a symbol of the critical apprenticeship of the senses that Kokoschka defended throughout his whole life.*

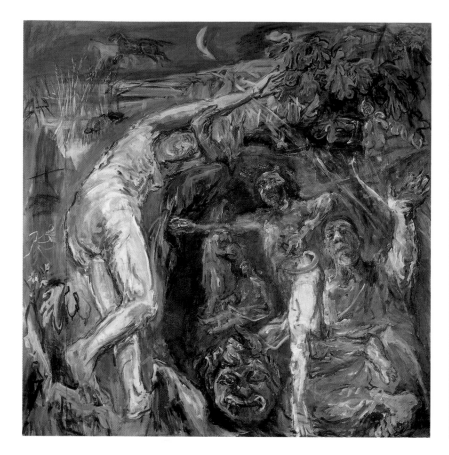
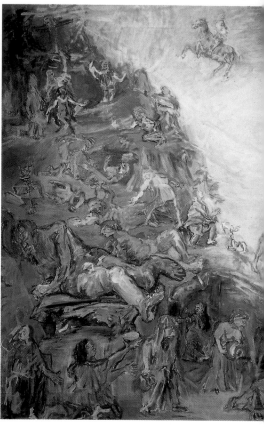

63 The Myth of Prometheus, *1950. The Baroque presence emerges here in the plentiful light: diagonal torrents, ascending spirals, perspectives which are shown from below in extreme foreshortening. In using this myth Kokoschka made a declaration in favor of liberty and progress, while—at the same time—he looked back to the Greek origin of these values, and to the pictorial basis of its figurative tradition. This painting represents a manifesto concerning the foundation that Kokoschka insisted was crucial for the moral reconstruction of a destroyed Europe.*

64 Morning and Afternoon (The Power of Music II), *1966. The Pan-like figure on the left exercises his power of fascination by means of music over the nymph on the right, who is seemingly immersed in a passive and serene ecstasy. Both the subject matter and the composition recall the 1909 double portrait of the Tietzes.*

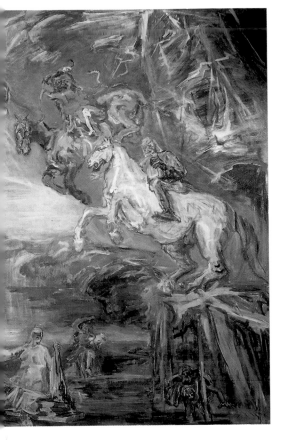

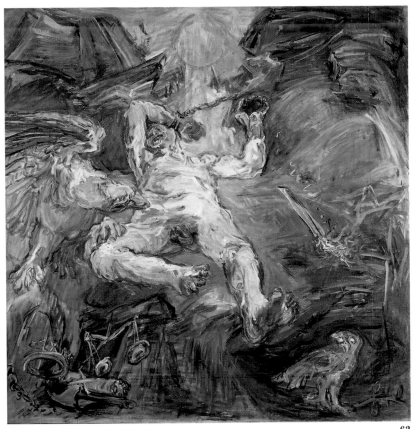

63

64

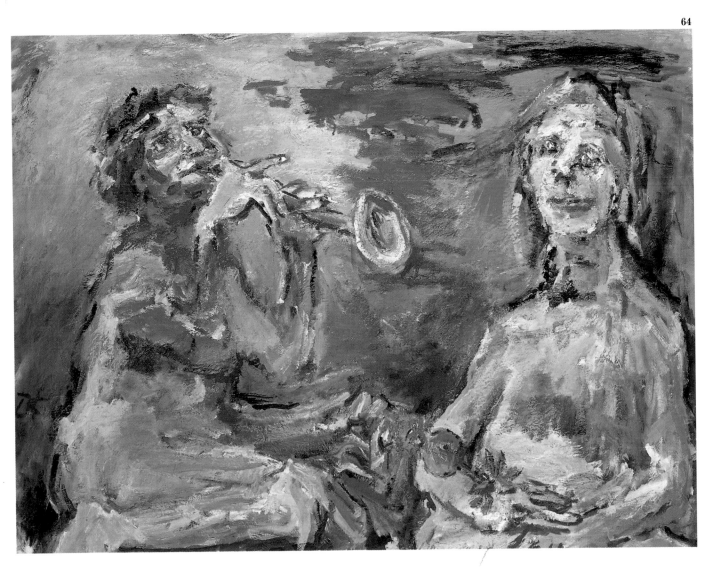

65

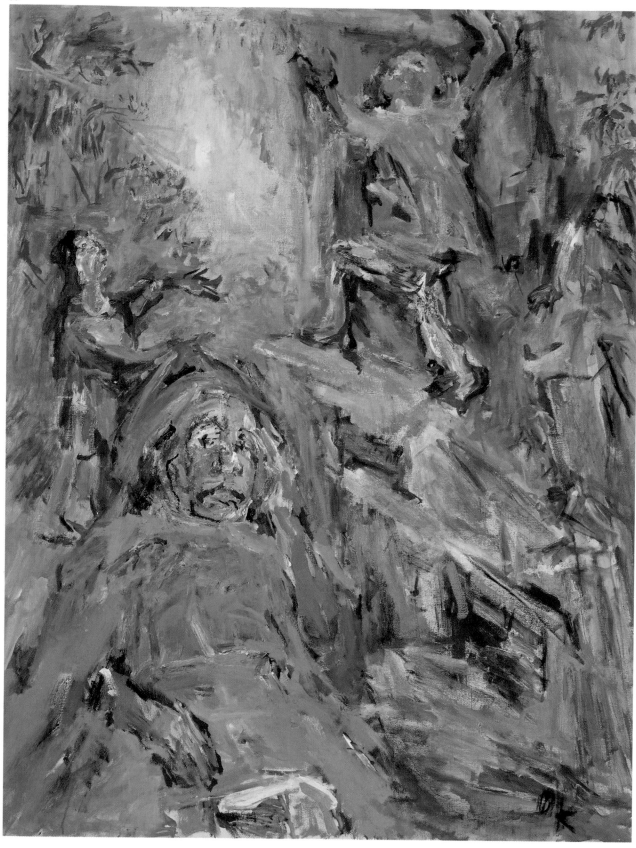

65 Peer Gynt, *1973. In this painting, the source of the legend is not Greco-Roman, but was drawn from popular tradition. Kokoschka achieved new heights of formal freedom in this painting, wherein the pictorial surface embodies a unique spatial plane of absolute fluidity and the painting is composed of ascending and descending spirals, with a strong concentration upon several nuclei of major expressive force.*

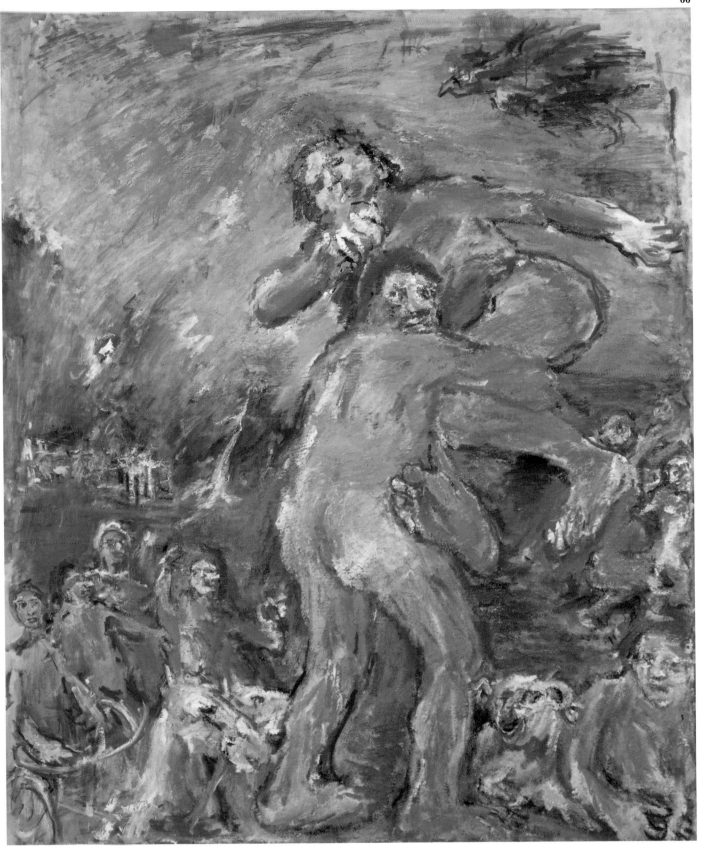

66 Theseus and Antiope, *1958–75. Here, Kokoschka called upon another seminal myth, of the same nature as that of Prometheus. The apparently informal construction—as reflected in the broad brushstrokes—is, in fact, the final distillation of that symbiosis between Baroque pictorial space and Expressionist configuration that comprised the basis of Kokoschka's pictorial language.*

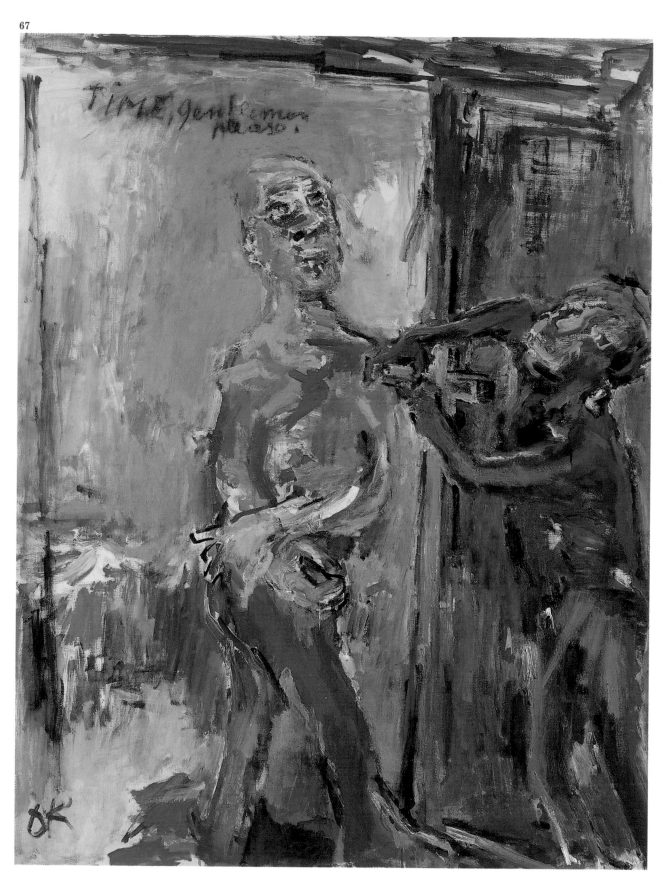

67 Time, Gentlemen, Please, *1971–72. Realizing that, due to the pressures of old age and failing sight, he would not be able to continue painting for much longer, Kokoschka produced this full length self-portrait that makes an ironic reference to the call heard in every British pub at closing time. The extreme concentration of resources, and the mastery with which the chords of primary colors—yellow, blue, green, and red—are harmonized, anticipate the revisions to Expressionism that would be undertaken by future German painters.*

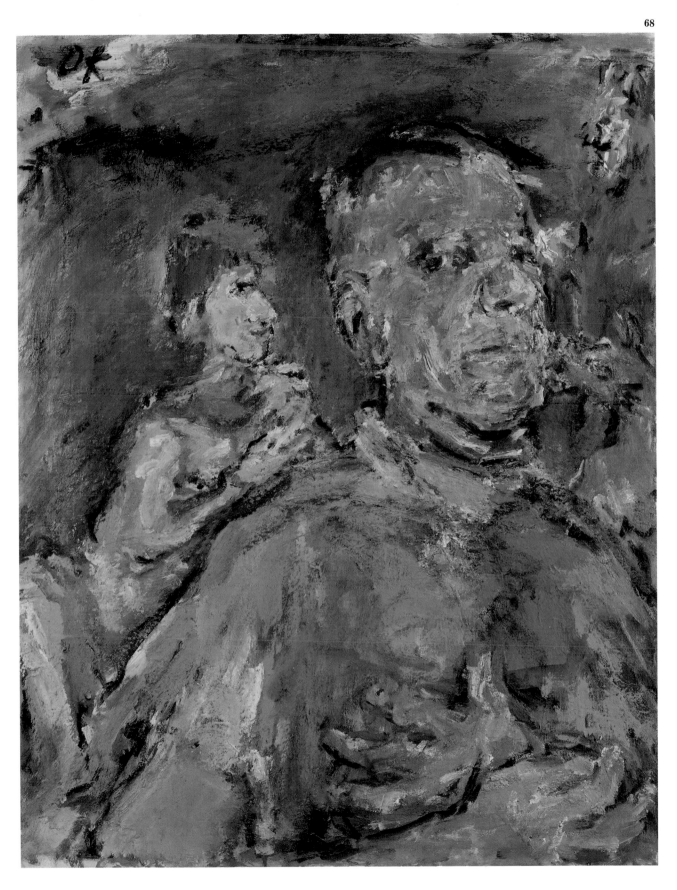

68 Self-Portrait, *1969. "The sum total of his work is like a painting of the whole world," an admirer of Kokoschka's paintings said in 1962. To put into perspective this artist's desire to express within his painting a distillation of all his impressions and experiences, one must consider the sequence of development in Kokoschka's work as a pictorial symphony whose most splendid notes exalt the process of truly "Seeing."*

List of Plates

1 Children Playing, *1909. Oil on canvas, 28⅜ × 42½" (72 × 108 cm). Wilhelm Lehmbruck Museum, Duisburg*

2 Martha Hirsch, *1909. Oil on canvas, 34⅝ × 27⅝" (88 × 70 cm). Private collection, United States of America*

3 Felix Albrecht Harta, *1909. Oil on canvas, 28¾ × 20¾" (73.1 × 52.5 cm). Hirshhorn Museum and Sculpture Garden, Smithsonian Institution, Washington, D.C.*

4 Adolf Loos, *1909. Oil on canvas, 29⅛ × 35⅞" (74 × 91 cm). Staatliche Museen Preussischer Kulturbesitz, Nationalgalerie, Berlin*

5 Hans Tietze and Erica Tietze-Conrat, *1909. Oil on canvas, 30 × 53½" (76.5 × 136.2 cm). The Museum of Modern Art, New York. Abby Aldrich Rockefeller Fund*

6 Peter Altenberg, *1909. Oil on canvas, 29⅞ × 28" (76 × 71 cm). Private collection*

7 Joseph de Montesquiou-Fezensac, *1910. Oil on canvas, 31½ × 24¾" (80 × 63 cm). Moderna Museet, Stockholm*

8 Herwarth Walden, *1910. Oil on canvas, 39⅜ × 27¼" (100 × 69.3 cm). Staatsgalerie, Stuttgart*

9 Count Verona, *1910. Oil on canvas, 27¾ × 23" (70.6 × 58.7 cm). Private collection, United States of America*

10 Les Dents du Midi, *1910. Oil on canvas, 31¼ × 45½" (79.5 × 115.5 cm). Private collection, Switzerland*

11 Alpine Landscape, Mürren, *1910. Oil on canvas, 27⅜ × 37½" (70.5 × 95.5 cm). Bayerische Staatsgemäldesammlungen, Munich*

12 Double Portrait (Kokoschka and Alma Mahler), *1912–13. Oil on canvas, 39⅜ × 35⅜" (100 × 90 cm). Museum Folkwang, Essen*

13 Alma Mahler, *1912. Oil on canvas, 24⅜ × 22" (62 × 56 cm). The National Museum of Modern Art, Tokyo*

14 The Bride of the Wind, *1914. Oil on wood, 71¼ × 87" (181 × 221 cm). Kunstmuseum, Basel*

15 Still Life with Cupid and Rabbit, *1913–14. Oil on canvas, 35⅜ × 47¼" (90 × 120 cm). Kunsthaus, Zurich*

16 The Friends, *1917–18. Oil on canvas, 40⅛ × 59½" (102 × 151 cm). Neue Galerie der Stadt Linz, Wolfgang-Gurlitt-Museum*

17 The Power of Music, *1920. Oil on canvas, 39⅜ × 59¾" (100 × 151.5 cm). Stedelijk van Abbemuseum, Eindhoven*

18 Self-Portrait with Doll, *1922. Oil on canvas, 31½ × 47¼" (80 × 120 cm). Staatliche Museen Preussischer Kulturbesitz, Nationalgalerie, Berlin*

19 Woman in Blue, *1919. Oil on canvas, 29½ × 39⅜" (75 × 100 cm). Staatsgalerie, Stuttgart*

20 Dresden, Neustadt II, *1921. Oil on canvas, 23½ × 31½" (59.7 × 80 cm). The Detroit Institute of Arts*

21 Young Girl with Doll, *1921–22. Oil on canvas, 36 × 32" (91.5 × 81.2 cm). The Detroit Institute of Arts*

22 Dresden, Augustus Bridge with Steamboat II, *1923. Oil on canvas, 25⅝ × 37½" (65 × 95.5 cm). Stedelijk van Abbemuseum, Eindhoven*

23 Dresden, Bridges of the Elbe (with Figure Seen from the Back), *1923. Oil on canvas, 25¾ × 37½" (65.5 × 95.7 cm). Museum Folkwang, Essen*

24 Self-Portrait with Arms Crossed, *1923. Oil on canvas, 43½ × 27⅝" (110 × 70 cm). Private collection*

25 London, Waterloo Bridge, *1926. Oil on canvas, 35 × 51⅛" (89 × 130 cm). National Museum of Wales, Cardiff*

26 Nancy Cunard, *1924. Oil on canvas, 45⅝ × 28¾" (116 × 73 cm). Sprengel Museum, Hannover*

27 Adèle Astaire, *1926. Oil on canvas, 38⅛ × 51¼" (97 × 130.5 cm). Kunsthaus, Zurich*

28 Karl Kraus II, *1925. Oil on canvas, 25⅝ × 39⅜" (65 × 100 cm). Museum Moderner Kunst, Vienna*

29 London, Panorama of the Thames, I, *1926. Oil on canvas, 35⅜ × 51⅛" (90 × 130 cm). Albright-Knox Art Gallery, Buffalo, New York*

30 Tigon, *1926. Oil on canvas, 37¾ × 50¾" (96 × 120 cm). Österreichische Galerie, Vienna*

31 Marczell von Nemes, *1929. Oil on canvas, 53⅛ × 37¾" (135 × 96 cm). Neue Galerie der Stadt Linz, Wolfgang-Gurlitt-Museum*

32 Lyon, *1927. Oil on canvas, 38¼ × 51⅜" (97.1 × 130.2 cm). The Phillips Collection, Washington, D.C.*

33 Jerusalem, *1929. Oil on canvas, 31½ × 50¾" (80 × 129 cm). The Detroit Institute of Arts*

34 Leo Kestenberg, *1926–27. Oil on canvas, 50 × 40⅛" (127 × 102 cm). Ruth Gladstein and Rachel Epstein Collection, Haifa*

35 The Arab of Temacina (Sidi Ahmet Ben Tidjani), *1928. Oil on canvas, 38¾ × 51½" (98 × 130.5 cm). Private collection*

36 Arab Women and Children, *1929. Oil on canvas, 34¾ × 50⅜" (88.5 × 128 cm). Private collection (on loan to the Tate Gallery)*

37 Vienna, View from the Wilhelminenberg, *1931. Oil on canvas, 36¼ × 52¾" (92 × 134 cm). Historisches Museum, Vienna*

38 Pan, Trudl with Goat, *1931. Oil on canvas, 34¼ × 51⅛" (87 × 130 cm). Sprengel Museum, Hannover*

39 Thomas G. Masaryk, *1936. Oil on canvas, 38½ × 51⅝" (97.7 × 131 cm). Museum of Art, Carnegie Institute, Pittsburgh*

40 Nymph, *1936. Oil on canvas, 37⅜ × 29⅞" (95 × 76 cm). Národni Galerie, Prague*

41 Olda Palkovská, *1937. Oil on canvas, 35⅜ × 26⅜″ (90 × 67 cm). Private collection*

42 Prague, View from the Wharf on the Moldau toward Kleinseite and the Hradcany IV, *1936. Oil on canvas, 38⅝ × 51⅛″ (98 × 130 cm). The Phillips Collection, Washington, D.C.*

43 Prague, Nostalgia, *1938. Oil on canvas, 22 × 29⅞″ (56 × 76 cm). Lord Croft (on loan to the Scottish National Gallery of Modern Art, Edinburgh)*

44 Self Portrait of a Degenerate Artist, *1937. Oil on canvas, 43¼ × 33½″ (110 × 85 cm). Private collection (on loan to the Scottish National Gallery of Modern Art, Edinburgh)*

45 The Red Egg, *1940–41. Oil on canvas, 24¾ × 29⅞″ (63 × 76 cm). Národni Galerie, Prague*

46 Michael Croft, *1938–39. Oil on canvas, 30 × 25″ (76.2 × 63.7 cm). Lord Croft (on loan to the Scottish National Gallery of Modern Art, Edinburgh)*

47 Sea Spider, *1939–40. Oil on canvas, 24⅞ × 30″ (63.4 × 76.2 cm). Tate Gallery, London*

48 Summer II (Zrání), *1939–40. Oil on canvas, 26⅞ × 32½″ (68.3 × 82.9 cm). Scottish National Gallery of Modern Art, Edinburgh*

49 Anschluss, Alice in Wonderland, *1942. Oil on canvas, 25 × 29″ (63.5 × 73.6 cm). Wiener Städtische Wechselseitige Versicherungsanstalt (on loan to the Historisches Museum, Vienna)*

50 That For Which We Fight, *1943. Oil on canvas, 46 × 59⅞″ (116.5 × 152 cm). Kunsthaus, Zurich*

51 Marianne-Maquis, *1942. Oil on canvas, 25 × 29⅞″ (63.5 × 76 cm). Tate Gallery, London*

52 Cathleen, Countess of Drogheda, *1946. Oil on canvas, 40⅛ × 29⅞″ (102 × 76 cm). Private collection*

53 London, Chelsea Reach, *1957. Oil on canvas, 29½ × 39¾″ (75 × 101 cm). Private collection*

54 Theodor Körner, *1949. Oil on canvas, 39⅜ × 31⅞″ (100 × 81 cm). Neue Galerie der Stadt Linz, Wolfgang-Gurlitt-Museum*

55 Louis Krohnberg, *1950. Oil on canvas, 39⅜ × 29½″ (100 × 75 cm). Private collection*

56 Pablo Casals, *1954. Oil on canvas, 33½ × 25⅝″ (85 × 65 cm). Private collection*

57 London, View of the Thames from Shell-Mex House, *1959. Oil on canvas, 36 × 48⅜″ (91.5 × 123 cm). Tate Gallery, London*

58 New York, Manhattan with the Empire State Building, *1966. Oil on canvas, 39⅞ × 53⅞″ (101.5 × 137 cm). Private collection*

59 Self-Portrait with Olda, *1966. Oil on canvas, 35 × 45⅝″ (89 × 116 cm). Landessammlungen Rupertinum, Salzburg*

60 Lake Leman with Steamboat, *1957. Oil on canvas, 31⅞ × 45⅝″ (81 × 116 cm). Oskar Kokoschka Foundation, Musée Lenisch, Vevey, Switzerland*

61 Saul and David, *1966. Oil on canvas, 39⅜ × 51⅛″ (100 × 130 cm). Tel Aviv Museum of Art*

62 Herodotus, *1960–64. Oil on canvas, 70⅞ × 47¼″ (180 × 120 cm). Österreichische Galerie, Vienna*

63 The Myth of Prometheus, *1950. Tempera on three canvases, 90½ × 90½″ ; 90½ × 98⅜″ ; 90½ × 90½″ (230 × 230 cm; 230 × 250 cm; 230 × 230 cm). Courtauld Institute Galleries, Princess Gate Collection, London*

64 Morning and Afternoon (The Power of Music II), *1966. Oil on canvas, 39⅜ × 51⅛″ (100 × 130 cm). Kunsthaus, Zurich*

65 Peer Gynt, *1973. Oil on canvas, 45¼ × 35″ (115 × 89 cm). Private collection*

66 Theseus and Antiope, *1958–75. Oil on canvas, 76¾ × 65″ (195 × 165 cm). Oskar Kokoschka Foundation, Musée Lenisch, Vevey, Switzerland*

67 Time, Gentlemen, Please, *1971–72. Oil on canvas, 51⅛ × 39⅜″ (130 × 100 cm). Tate Gallery, London*

68 Self-Portrait, *1969. Oil on canvas, 35½ × 27¾″ (90.5 × 70.4 cm). Private collection (on loan to the Tate Gallery)*

Series Coordinator, English-language edition: Ellen Rosefsky Cohen
Editor, English-language edition: Adele Westbrook
Designer, English-language edition: Judith Michael

Page 1 *Poster for the art journal* Der Sturm, *1910*

ISBN 0–8109–4682–3

Printed and bound in Spain by La Polígrafa, S.L.
Parets del Vallès (Barcelona)
Dep. Leg.: B. 22.009-1995